Collins

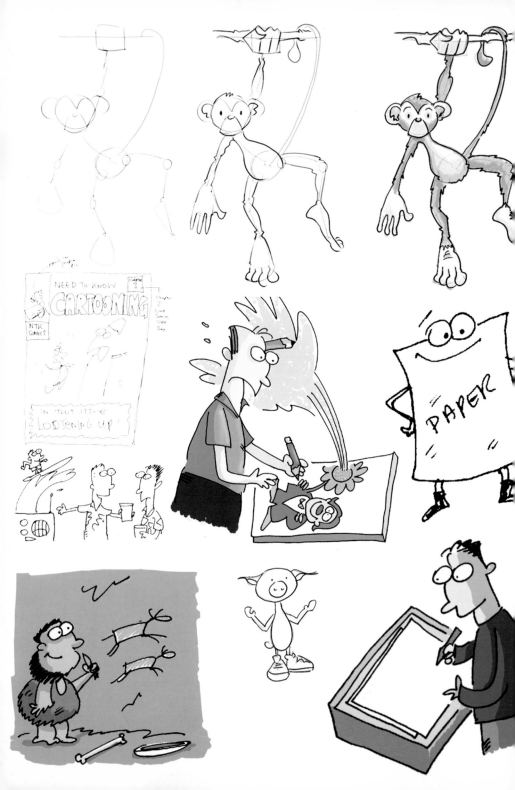

cartooning

The Best One-Stop Guide to Drawing Cartoons,
Caricatures, Comic Strips, and Manga

John M Byrne

Collins

First published in 2008 by
Collins, an imprint of
HarperCollins Publishers
77–85 Fulham Palace Road
Hammersmith, London W6 8JB

The Collins website address is:
www.collins.com

Library of Congress Cataloging-in-Publication Data
Byrne, John, 1963-
Cartooning / John M. Byrne. -- 1st US ed.
p. cm.
Includes index.
ISBN 978-0-06-147794-2
1. Cartooning--Technique. I. Title.
NC1320.B97 2008
741.5'1--dc22

Created by: **SP Creative Design**
Editor: **Heather Thomas**
Designer: **Rolando Ugolini**
Lead artists: **John Byrne and Spencer Hill**
Contributing artists: **Evil Twin Artworks, Alex Hughes, Meg Jones,
James Pearson, Leonard Noel White**

ISBN: 978-0-06-147794-2

Printed and bound by **Printing Express Ltd., Hong Kong**

Contents

Introduction 6

1 **The history of cartoons** 8

2 **Loosening up** 14

3 **Materials** 20

4 **Basic cartoon drawing** 30

5 **Bringing your cartoons to life** 52

6 **Cartoon humor** 72

7 **Caricature** 96

8 **Drawing comic strips** 118

9 **Manga** 142

10 **Putting cartoons to work** 164

Glossary 186

Need to know more? 188

Index 190

Introduction

Who doesn't enjoy cartoons, whether it is the sharp, satirical wit of daily political cartoons or the warm and familiar humor of your favorite comic-strip character? Or perhaps your preference is death-defying adventure in the company of a superhero or manga warrior.

Whatever your own cartoon likes and dislikes, it is extremely unlikely that you would be reading this introduction if you were not one of the many people who enjoy cartoons and have also thought at some point, "I wish I could do that." You may even have already started cartooning and are now hoping to polish your skills to a more professional level.

The good news is that everyone can "do that," whether their goal is simply to draw cartoons for fun, or to work one day in what is a fast growing, diverse industry. In this book, you will learn the basic drawing techniques on which all cartoonists build their pictures, regardless of whether the end result is a funny animal or a fearsome super villain. You will be introduced to different styles, ranging from manga to caricature, and you will also learn to produce jokes and stories for your newly created characters to act out.

This book features work by several cartoonists with different styles. The key to making the book work for you is to try all the techniques and ideas, step by step, in whatever style is comfortable. Some of the ideas will work better than others, depending on your likes and dislikes and where you are currently at—don't worry if you've never drawn before. The more ideas you try, the more fun you'll have—and having fun is the best way to ensure your readers will, too.

Everything you need to know to be able to draw cartoons is contained in these pages, and if you've got something to draw with, something to draw on, and your sense of humor and adventure, you already have everything you need to take advantage of it.

1 The history of cartoons

Although the term "cartoon" as we know it is relatively recent, the idea of using simple pictures to make a point, a joke, or tell a story is very ancient. The ancient Greeks often used pictures that told stories to decorate their vases, while many people consider the hieroglyphics used by the ancient Egyptians to be the first comic strips, complete with speech balloons.

The popularity of cartoons

Portrait art and sculpture was often used to celebrate and flatter important people in the days before photography, and cartoonists quickly discovered that they could get away with insulting people in humorous and exaggerated drawings in a way that was not possible in other forms of art, so caricature became very popular.

must know

As originally used, the word "cartoon," which comes from the Italian word *cartone*, didn't mean "funny drawings." A *cartone* was a full-size drawing done as a first step to producing a painting or a tapestry. Original cartoons by artists, such as Leonardo da Vinci and Raphael, are valuable—but they are not very amusing.

Humor and storytelling

Developments in printing technology really brought cartoons and comics into the limelight. Satirical magazines, such as *The New Yorker* in the United States and *Punch* in England, made stars of their top cartoonists, and popularized the single panel "gag" cartoon. When newspapers began to offer whole sections of cartoons and comic strips to their readers, and they discovered that it was often the "funnies" to which even the grown-up readers turned first, it was only a matter of time before cheap comic books began to be sold as products in their own right.

Although cartoons and comics are often associated with humor, they can just as easily be used to make important political points or to tell dramatic stories—in fact, television and movie directors are often encouraged to study comic strips to learn how to tell gripping stories in pictures.

Comic books initially featured reprints of popular newspaper comics, but eventually they began to focus on creating their own stories and long-running characters. In England, comics, such as *The Beano* and *The Dandy*, came out weekly and featured several different characters in each issue,

whereas in the United States the preference was for monthly comic books with popular characters, such as Superman and Batman, and later Spiderman and The Fantastic Four.

It wasn't long before television and movies picked up on the appeal of comics, and there have been many successful animated and live-action television shows and even blockbuster movies based on popular comic-strip characters.

Cartoons and comics have always been just as popular in the rest of the world as they are in the United States and Great Britain. European countries, such as France and Belgium have their own cartoon superstars, such as Asterix and Tintin, while in Latin America, India, and Africa, comic books are widely used not just for

Cartoon heroes have often been featured in movies and television shows, but the special effects have improved over the years.

Cartoons and comic strips are used worldwide for educational and information campaigns.

In the eighteenth century, humorous engravings were often very detailed with a lot of small jokes in one drawing. They were designed to be explored and enjoyed for hours at a time.

entertainment but also for a broad range of educational purposes. Increased global communication also means that there is a lot more crossing over of cartoon styles from artist to artist as well as from country to country.

Almost every country in the world now has its own well-loved cartoon and comic book characters.

Manga

Like Western cartoons, the history of Japanese manga comics stretches far back into the time when pictures were produced via woodblock printing, which is one of the reasons why this type of comic has such a bold dramatic look. Manga-style comics have now become extremely popular all over the world, as has its animated cousin anime, and even traditional Western comic heroes have had their adventures retold in manga versions.

New developments

As new forms of technology and media continue to be invented, there will probably be further developments in the world of cartooning and comic strips—not just in how the pictures are drawn but also in the ways in which they are used.

However, whatever the future holds for this art form, the basic drawing and idea-creating techniques used will probably be the ones that have been utilized throughout the centuries. These will be the ones you'll be learning yourself in the rest of this book, so that you, too, can be part of this ongoing cartoon adventure.

want to know more?

- Some comic stores display old comic books and original cartoons.
- Most public libraries have a "graphic novel" section with the latest cartoons and comics plus reprints of classic comics and cartoons.
- Visit the Ohio State University's Cartoon Research Library at www.osu.edu
- See Don Markestein's huge online collection of cartoon information at www.toonopedia.com
- For the history of Manga, log on to www.animeinfo.org

2 Loosening up

"Do you usually draw with your right hand or your left hand?" goes the old joke. "Neither" is the time-honored reply, "I usually draw with a pencil." To draw cartoons, you need more than just your favorite drawing instrument. Drawing requires the full participation of your entire body—your eyes and brain as well as your hands. As well as doing the physical exercises needed for coordination, it makes sense to create the best possible work space for all of this to happen. This chapter ensures that you achieve both of these vital goals right from the beginning of your cartoon career.

Doodles and drawing exercises

It pays to warm up before you start work. You wouldn't think of starting a marathon or some other sports activity without doing some warm-up exercises and the same is true of cartoons. Cartooning involves your body and your brain, so it pays to warm up both of them before starting your actual drawing projects.

must know

Cartooning ability, like any other skill, does not develop overnight. It only takes a few minutes a day to develop good habits, but only you can decide whether you are actually prepared to invest those few minutes. If you do, you will see that the greater drawing freedom you have more than makes up for having to follow even these simple rules.

Nice and easy

The more ease with which you can produce your drawings, the more easy on the eye they will look to your readers, something that is equally important whether you are creating light-hearted jokes or stories to make people laugh or aiming to generate a sense of excitement and drama in your graphic novels or manga adventures.

Practice first

Many artists—both beginners and professionals—can benefit from putting aside some time at the beginning of every drawing session to simply loosen up their arms and hands by shaking them out and making sure they are at their most flexible. The brain can also benefit from loosening up. Try giving

Many beginners assume that drawing uses just the hand and wrist and grip their pen or pencil much too tightly. Professionals know that using the whole arm produces a much more flowing and better looking style.

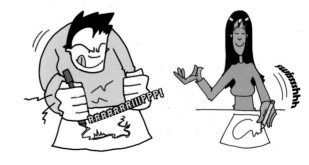

yourself the freedom to do some random doodling on a spare sheet of paper before you turn your attention to today's drawing task. From zigzag lines to strange shapes and simple cartoon pictures, exactly what you draw does not really matter; what does matter is the practice your brain and body are getting in working together as freely as possible before their actual work begins.

Random doodles, such as these, help loosen the drawing arm and get the brain cells working.

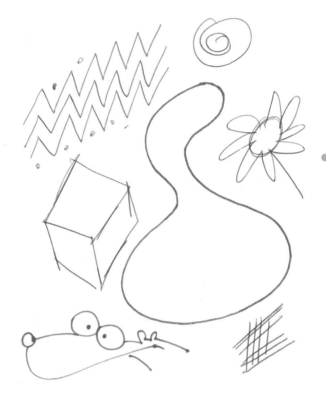

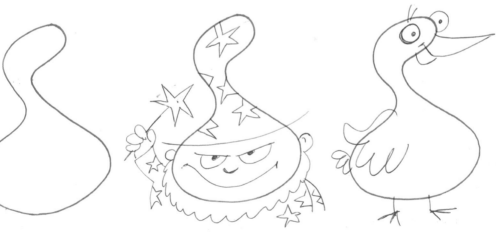

Although the aim of random doodling is not to produce an end product, it often results in shapes and ideas that can be adapted into successful cartoons.

Your cartoon studio

Being serious about your work space produces funnier cartoons. One of the joys of cartoons is they can be drawn anywhere with the simplest materials, but if you are serious about developing your cartoon style and producing work to the highest standard, it helps to have a special work space set aside for your work.

must know

Always position your computer well away from the drawing board. While the Internet can be useful for finding reference material, much valuable drawing time can be wasted with aimless Internet surfing.

Lighting and seating

Although your working area may simply be a quiet corner of your bedroom or living room instead of a professional studio, the basic items of equipment that you would find in both locations are not very different. Most cartoonists start off with just a few essentials and then build up their work space as their interest and enthusiasm grows.

Perhaps the most essential elements of any area in which you are planning to draw are good lighting and seating. Professional artists always make sure

The same ingenuity you use for cartoon ideas can help enhance your work space. A light box is very useful for tracing drawings, but if you don't have one, taping your drawings to a window can achieve the same effect.

they have enough natural light to work in, and, if they have to use artificial light, they normally choose bulbs that replicate natural lighting as closely as possible; these are widely available from most art and electrical stores. If you are going to spend long hours at the drawing board, it is also very important to make sure your posture is correct. An adjustable chair will be a great help in keeping you flexible and giving you proper back support.

Useful tips

1 If possible, position your drawing board near a window, so that you have good natural light.
2 You can buy professionally made drawing boards with rulers and measuring devices attached, or you can make one yourself. Make sure that the wood you choose is smooth enough to draw on top of. Because cartoonists often draw pictures at a larger size than they are printed at, ensure that your board is large enough to hold bigger sheets of paper.
3 An adjustable lamp can be angled to provide extra lighting for detail work.
4 Filing cabinets and drawers come in many shapes and sizes and are very useful for keeping your art supplies, finished cartoons, and reference materials organized. If you plan to seek work as a cartoonist, you will need somewhere to keep financial records.
5 A computer (preferably with Internet connection), along with a printer and scanner, are increasingly becoming as important to the cartoonist as pen, ink, and paper. A laptop or other portable device gives you even more flexibility. Even if you're not a gadget fan, it is worth keeping an eye on developing technology to identify potential new tools.

want to know more?

• Pick a regular time for drawing practice based on whether you are more creative early in the morning or at night.
• In addition to your regular drawing place, carry some paper and pens with you as often as you can—you never know when inspiration for a cartoon will strike.
• For warm-up ideas, challenges, and ways to spark your creativity, see www.successful cartooning.com

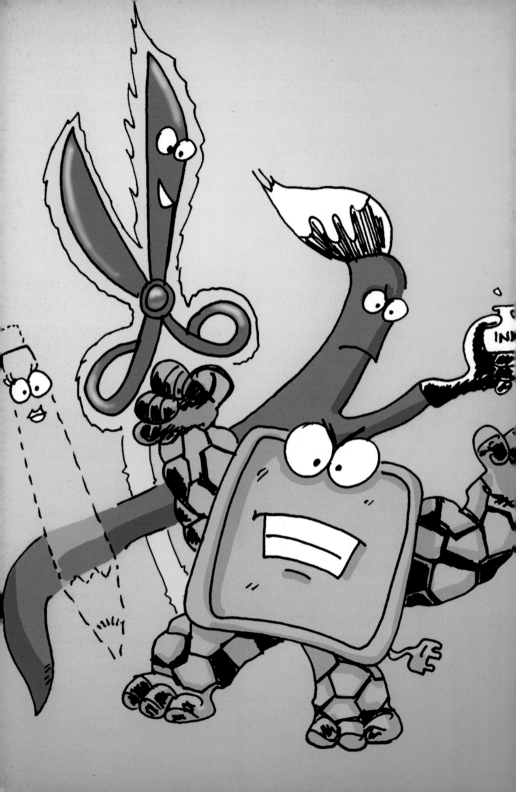

3 Materials

You can draw great cartoons with almost any materials. However, the choices you make can make a big difference to how your finished cartoons look, and choosing the right tools for the right job can be a major factor in the success of your final product. In this chapter, you'll learn about the many types of tools and materials available to you and get a chance to experiment until you find the ideal ones for you.

Pencils and pens

Even the simplest drawing tools offer a wide range of choices. If you've only ever drawn with whatever is on hand, you'll be surprised at how making a conscious choice improves your work.

must know

When you switch from medium to medium, such as by inking over a penciled drawing, remember that not all of the pencil effects, such as smudging, will be possible in the final inked version.

A range of materials

Enter any art store and there will be a huge range of pencils and pens to choose from. Hopefully, you will also find some paper pads to test drive the writing equipment on display, and it is a very good idea to try drawing one of your favorite cartoons with several different pencils or pens to get an idea of how each type of point or nib can change the look of your own drawing style.

Below are listed some of the most common types of pencils and pens that are used by professional cartoonists and what they are used for.

Pencils

Pencils are most often used by cartoonists for drawing preliminary sketches, even if they are to be inked over later on. In fact, it is precisely because of the fact that once the ink has dried, the underlying

A 2H pencil creates a thin precise line, as shown here (right). Using a Using a 4B pencil on the same drawing produces a darker and more flexible effect (far right).

Using a B pencil on a drawing gives you the opportunity to deliberately smudge the picture to create tonal effects.

pencil sketch can be erased that pencils are such useful tools for those cartoonists whose work will eventually be printed.

Pencils are produced in a standard range of weights on the HB scale. H pencils, such as 2H or 4H, contain extremely hard thin lead, which creates a precise and thin line on the page. This is useful for detail work and, because it is so thin, for inking over later. B pencils, with a much darker and softer line, are often used for sketching and drawing from life.

When you're inking over a pencil drawing, any elements you want to leave out, such as the overlapping line on the planets, can be left unlinked and erased.

Pen and ink

There are many different sizes and makes of pen nib available, ranging from fountain pens to technical pens. Like pencil points, some pen nibs are more flexible than others, and you will need to experiment to find the one that best suits your drawing style. It is extremely common for cartoonists to use more than one pen on a drawing or strip, with narrower lines used for detail and wider ones added to give weight and definition.

When you find a pen that works particularly well for you, it is a good idea to purchase several of them at a time—you don't want to be in the position of having to change pens halfway through creating a strip or a series of cartoons and discover that a new pen size changes the appearance of your drawing style completely.

It is always worth experimenting with each pen before you start drawing to see how many effects you can use.

Brush and ink, or paints

While pen and ink drawings are ideal for precision, applying ink and paints with a brush offers greater freedom and flexibility. Like pens, brushes come in different sizes, so it is possible to utilize a narrower brush for the details of your drawings and then use a wider one to cover larger areas with ink as required.

Different mediums

As with pen and ink drawing, the best way to find out which brushes best suit your own drawing style is to experiment. Working with a brush gives you the option of adjusting the intensity of color in your work to the type of cartoon you are doing. You can use bright solid paint colors in poster or acrylic paints for humor or action adventures, whereas, if you are aiming for more atmospheric stories, you might opt for a more delicate watercolor effect. You can also dilute your existing inks to create a wash effect on your pictures—a look that is particularly popular with editorial cartoonists.

Drawing with a pen produces a precise line (top). The same picture drawn with brush and ink (above) has a little less precision but gains more energy.

Diluting inks with a little water will give your cartoon pictures an atmospheric wash effect.

A detail brush, together with a little patience, creates delicate work on manga drawings, such as this one.

As illustrated here, using watercolors adds to the delicate effect of the manga drawing.

Poster or acrylic colors can be used to produce a bolder, brighter effect.

Using just one color of ink can create an extremely atmospheric look.

Paper and corrections

Just as your drawing tools will affect the look of your finished cartoons, the paper you use to draw on makes a difference, too. For both pen and brush artists, the ideal drawing surface should be smooth and able to hold ink well, so the line you draw stays precise when the picture is reproduced in the printing process.

watch out!

When going over one medium with another, such as ink on pencil, it is very easy to smear the line or stain the paper with your hand. Draw with scrap paper under your drawing hand to prevent this.

The right surface

The paper or board you draw on must be durable because you will often need to erase pencil lines, cover errors with correction fluid, or paste over sections of your drawings that you want to amend.

While smooth high-quality drawing paper or bristol board is the standard surface cartoonists work on, don't be afraid to experiment on other surfaces; using a rougher paper can bring out the best in conté or charcoal cartoons, and drawing on colored paper often creates an interesting background for your characters to perform against.

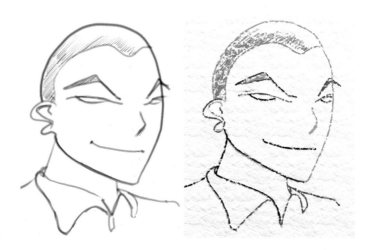

Drawing a smooth character on a rougher paper (far right) will create a more rugged result.

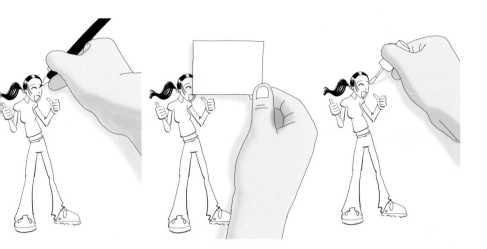

You can correct your mistakes by pasting a new section over the part of the drawing you want to change, or simply by using some correction fluid.

A rougher colored paper brings out the full effect of this cartoon drawn with Conté crayon.

Using computers

Although a computer can never replace the cartoonist's art, it can enhance your results very easily and it is fast becoming an essential tool for both professional and amateur cartoonists.

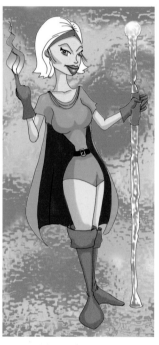

For fantasy cartoons, the computer's ability to create striking backgrounds and color effects is particularly useful.

The benefits of computers

Even if you prefer to do your cartoons by hand, simple computer effects can expand the ways in which you can present your finished cartoons, make some of the more time-consuming tasks easier, and sometimes produce effects that would be difficult or simply impossible without technology.

Once you have converted a drawing to computer form (see page 168), you can cut pieces out with a click of your mouse, as well as alter the composition and correct mistakes. For many cartoonists, this is a great step forward because there is no "undo" button on a brush or pen in the real world. A computer offers you many time-saving tools and techniques, such as combining elements of different cartoons and creating crowds from one drawing.

Clip art images

While this book aims to encourage you to believe that there is nothing you will not be able to draw once you have mastered some basics and are prepared to put in a little practice, computers can even provide you with ready-to-use clip-art images of almost any element you would like to use in your cartoons, ready for you to combine and add your own captions to create cartoons that do not even require you to draw them.

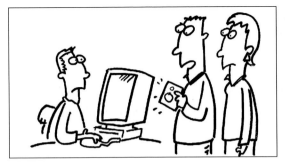

The original cartoon is scanned into the computer and then colored before shading effects are added. In the final version, the computer has been used to combine the drawing with a photographic background.

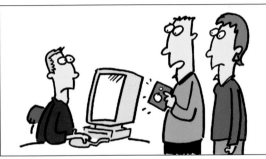

want to know more?

- In your local art store, try out different drawing tools to see what effects each one can achieve.
- Take a cartoon to a computer store and ask the staff to show you the effects of different types of software.
- Go to exhibitions of original work by famous cartoonists. Examine the pencil lines, paste overs, and other corrections that are still visible!
- A worldwide list of art museums and galleries is available at www.artcyclopedia.com

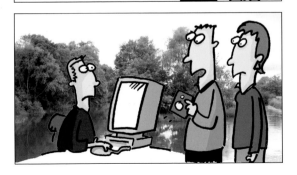

4 Basic cartoon drawing

No matter what type of cartoon you are
interested in drawing—funny, adventurous,
manga-style, or a combination of all three—
the basic building blocks of cartooning are
some very simple shapes and techniques.
Most people can already draw these easily,
whether or not they consider themselves
artists. It is how you combine these simple
elements that makes the difference.

Basic cartoon shapes

The best starting point is the simplest. The principal difficulty for anyone learning to draw cartoons is that the drawings usually seen are finished ones with colors, corrections, and polished elements already added in. No matter how impressive the end product, it is unlikely to have begun as such an impressive sight.

Simple shapes

Just as there are a very small number of individual notes in music, yet the possible combinations are almost infinite, the basic elements used to build up most cartoon drawings can be broken down into some very simple and common shapes. For the purposes of illustration, the most common shapes are shown here: circles, squares, triangles, and the all-important banana or sausage shape, which can be bent into whatever form the cartoonist requires. Once you have mastered drawing these shapes on their own, you should have no difficulty using them to construct your cartoons.

Adding shadow can help to make shapes look more solid.

Sketching actual objects with a light source helps you learn where to place shadows.

Practice is imperfect

Great artists, such as Michelangelo, were feted for being able to draw perfect circles and ellipses without needing any drawing instruments. If you can do the same, that's wonderful, but it is not necessary to be able to draw even the simpler shapes shown here precisely to be able to use them in cartooning. Drawing them energetically is much more important. Any variations that creep into your work as you practice will simply make your own style all the more distinctive and individual.

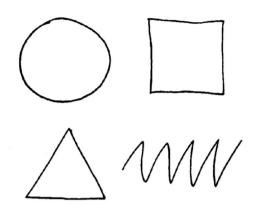

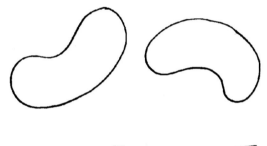

If you can draw the simple shapes above, you can draw cartoons—or anything else.

You can make basic cartoon shapes more three dimensional by adding perspective (right), curvature (below), and shading (below right).

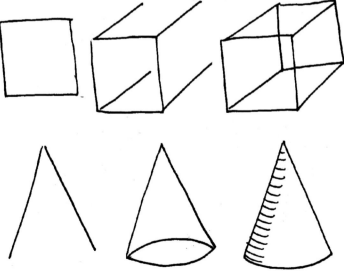

Drawing cartoon people

Every person is unique, but every drawing starts out the same. For many first-time artists, it is better to think of picture making as building instead of drawing. Whatever your cartoon idea, getting it on paper is a simple matter of putting simple shapes, such as the ones on the previous page, together in the right way.

must know

As you practice building up figures from basic shapes, start to look at your favorite cartoon characters and try to identify the shapes the artist may have used to begin the finished picture. You will often find they are very similar to the ones used here.

The basic figure

It does not matter which part of the body you draw first, whether it is an oval shape for the torso or a round shape for the head. The aim of your first drawing is simply to create a very basic body shape to which you can add details later on. If you draw this shape in pencil (or you have some tracing paper on hand, so you can go over it later), you can make as many adjustments and corrections as you want until you have a figure you are happy with.

Add on sausage shapes to make the arms and legs, and ovals for the hands and feet—again, don't worry too much about making them look perfect because you can make any adjustments later. If any shapes, such as hands, seem difficult, you can simply break them down into smaller shapes—for example, a hand might be an oval with smaller sausages attached for the fingers.

Adding detail

When you are happy with the basic body shape, you can start to add the details needed to turn it into an individual character. Draw straight over your original body shape—don't worry about crossing lines—if you have drawn your basic shape in pencil, you can

always erase it and just ink in the lines you want to keep later on. In the examples illustrated below, some very simple facial features have been added to a basic body shape, and the pose remains a very simple one. Notice how the clothes change our perception of the character. You will learn more about how to create emotion and movement in the next chapter (see page 50).

Start off with a simple oval-and-ball combination.

Next, add sausage shapes to create the arms and legs.

Simple features are then added to create the face.

Adding clothes and a hairstyle to these basic shapes will make a simple cartoon character.

Different features and dress can help to turn the same body shape into a different person.

With the right additions, the same shape can be used to create almost any character.

Rounder shapes will help create a rounder character.

Adapting the basic shape

Just like real people, cartoon characters come in many different shapes and sizes. Having mastered the basic figure, you can start having fun with stretching and squashing the shapes that are part of it to suit the character you are aiming to draw. For a very tall character, elongate the figure shapes accordingly, whereas if you are drawing a rounder person, you can make the basic shapes rounder, too. Really exaggerating the shapes can help you produce comical-looking characters before you create jokes and humorous stories for them to perform in.

Get to know proportion

Although the shapes that you use to build up your characters are simple ones and are often exaggerated, they still have to obey basic proportion

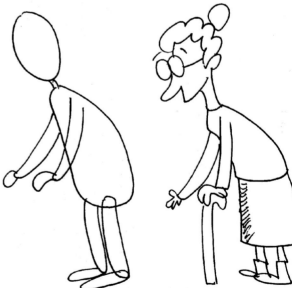

Giving the figure a stoop helps to create the impression of age.

rules. One particularly useful principle to be aware of is the fact that the younger a character is the larger their head will be in relation to the rest of their body. Getting this wrong can create confusion, because it can be difficult otherwise to distinguish your drawings of young people from adults of small stature. At the other end of the age scale, you can also make your characters appear older by adding a stoop to your basic shapes.

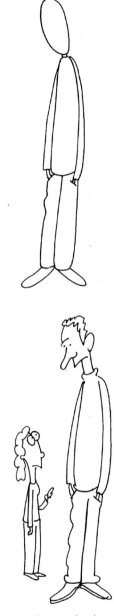

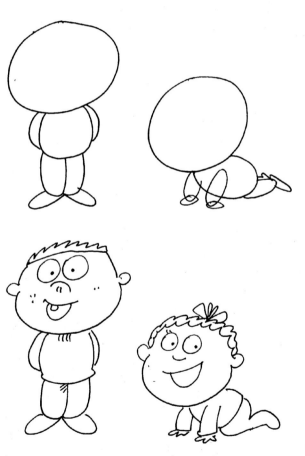

Young children have big heads in relation to their bodies.

You can elongate the shapes to portray a taller character.

Basic cartoon animals

The same collection of basic shapes that are used to create cartoon people can be combined to create literally any animal you care to imagine (including birds, fish, and insects).

Starting from the simple shapes

Start by creating a simple drawing using basic circle and sausage shapes as you would when drawing a human figure. The simple four-legged version shown on these pages can be adapted to suit a variety of animals. You can add refinements as your drawings become more practiced.

All creatures great and small

Although you will always use the basic shapes as your starting point, there is obviously a much wider variation in animal shapes and sizes than there is when drawing humans, so for some animals and for other members of the natural world, you may need to use a little more imagination and either less or more shapes to create your figure template.

Same shapes—different animals

In the same way that changes to the details can transform the basic person shape into a variety of different characters, you can derive a number of different breeds and species of animals from the same starting point. A particular challenge when drawing animals of the same species is to make each one into an individual character. Using distinctive markings and colorings can help you considerably with this.

Some animals start from a different shape to the basic animal figure (opposite).

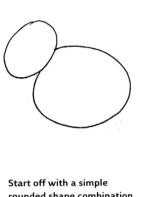

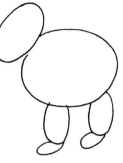

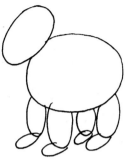

Start off with a simple rounded shape combination.

Next, add some sausage shapes for two of the legs.

Two more legs complete the basic animal shape.

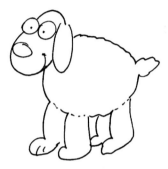

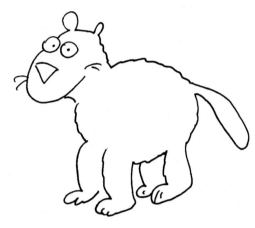

Different details can be added to create different animals, as shown above and right.

The animal shape can be refined and adapted to suit the animal that you want to draw.

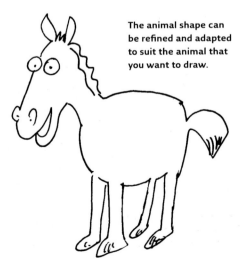

As with the basic animal shape, a basic bird shape can be turned into different species by adding distinctive details to it.

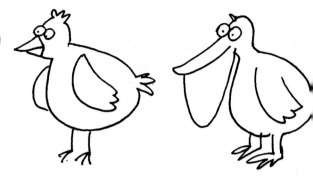

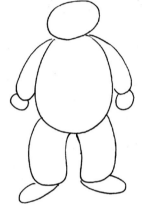

Anthropomorphism

Anthropomorphism is a big word for a very familiar cartoon device—drawing animals but giving them human characteristics. Many humanized cartoon animals often wear clothes and use everyday props, too. The degree to which you make your character realistic or more cartoonish is up to you and the story or joke on which you are working.

The basic person shape (above) can also adapted to create an anthropomorphic animal (right).

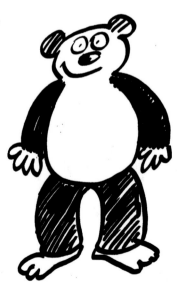

This anthropomorphic animal is more closely based on a real panda.

Fantasy creatures

Cartooning gives you the freedom to create purely fantastic characters, ranging from mythical creatures to space aliens— whatever you like. Even then it is often a good idea to include elements taken from real animals to give a degree of credibility.

This dragonlike creature incorporates elements from drawings of real lizards.

The influence for this cartoon dragon comes more from other cartoons than realistic animal features.

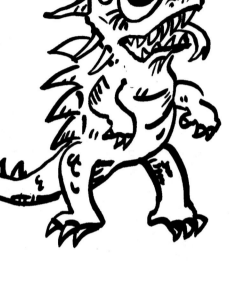

must know

If you are already an experienced artist, then challenge yourself to go beyond simply drawing generic dogs or cats or whatever species of animal you're working on. Try to identify the characteristics of the individual breeds and then include them in your pictures.

Creating props and costumes

Cartoon characters need a cartoon world. If you have been practicing with building up your cartoon characters—whether human or animal—from basic shapes, you will know by now that combining and adapting the fundamentals will give you a framework on top of which you can draw almost anything.

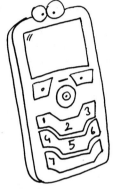

Like this cell phone, almost any cartoon object can be brought to life by adding facial features.

Constant creation

Almost all cartoonists, even those who have the simplest styles or who only work with a small cast of regular cartoon characters, will find themselves constantly being called upon to take on new drawing challenges, whether it's creating a new environment for their characters to perform in or new props for them to use in their adventures.

It is in this important area—being able to turn your hand to drawing anything—that the basic shapes system really helps. Instead of being limited by what you can and can't draw, you should aim to

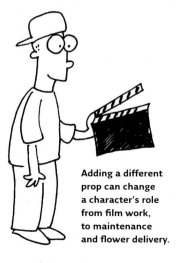

Adding a different prop can change a character's role from film work, to maintenance and flower delivery.

be able to consider any object or item that is

basic shapes that will allow you to draw it.

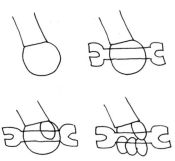

Simplicity is the key

Because cartoons are an art form that sets out to communicate its messages, whether they are funny or dramatic, as directly and with as much impact and punch as possible, simplicity is an important goal when you are creating a world in which your characters will live. You want to have sufficient information in your pictures to enable your reader to know what is going on but without distractions, so that your characters, jokes, and stories don't get lost in a mass of lines and detail.

As with whole figures, drawing complicated elements, such as hands and the props they hold, becomes simpler the more the shapes are broken down.

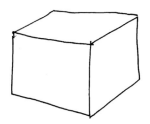

It can be the starting point for a treasure chest.

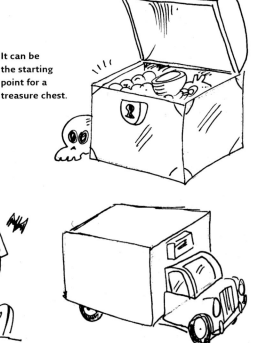

A simple block shape can become any number of objects, as shown here.

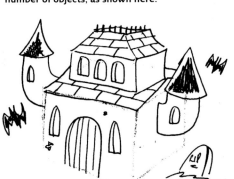

It can be transformed into a fantasy castle.

It can even be changed into a truck.

A sphere can be transformed into a pumpkin.

A cone shape forms the basis for a teepee.

This snowman is constructed by combining spheres and then adding seasonal details.

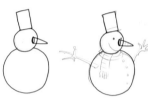

must know

Big or microscopic, no matter how detailed, there is no object you will need to draw that cannot be broken down and simplified into some basic shapes. If you are struggling with drawing the whole object in this way, try taking different parts of it, breaking them down into the basics, and then working on the details once you have combined the basic elements back together.

Realistic versus cartoonish

An interesting question that cartoonists often have to consider is how realistically they should draw the settings that surround their characters. The ones who draw fantasy-based characters opt for an equally fantastic background to their adventures. Other artists believe that if your characters are either very exaggerated or have superhuman powers, drawing them in a realistic environment increases the general

In this 1960s look, some elements are exaggerated for deliberate comic effect.

believability of the story. There is not necessarily a right or wrong answer to this. Experiment in your own work and find out what works best for you (you may find that different approaches work for different cartoon projects).

Costumes

You have seen already how simply changing a character's costume can create a whole different personality, and there is certainly nothing that gives a cartoon or comic strip a more atmospheric feel than getting the costumes right. Although the more research you do, the more your costumes will look authentic, getting them right does not necessarily mean that you have to be boringly literal and historically accurate when drawing them.

It can be very effective to get the details right in a historical or military costume but also to exaggerate some of them, such as belts, buckles, or medals to produce a more comic effect.

watch out!

Keep an eye on changing fashions in costume and object design. Young people today do not dress in the same style as you did when you were young (even if you were young recently) and the design of cars, phones, and many other objects is constantly shifting. Unless you want a historical effect, your costumes and props should look contemporary.

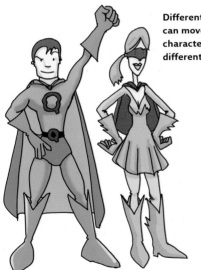

Different costumes can move these two characters into different time periods.

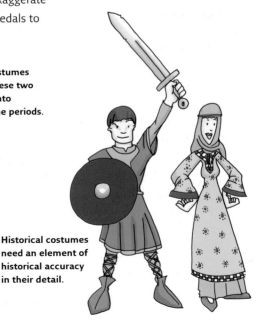

Historical costumes need an element of historical accuracy in their detail.

Backgrounds and locations

All the world's a stage, and with just a few pen strokes you can change a scene with ease. Building your backgrounds repertoire allows you a world of variety when setting out your ideas.

Setting the scene

As with all the other aspects of cartooning, drawing backgrounds and scenery accurately is a challenge for the beginner. However, even for the experienced artist, setting the scene without taking anything away from the main action can often be challenging.

Identifying the vital elements

Just as cartoon characters have their individual characters and trademark visual elements, often you need only one or two vital and immediately identifiable items or landmarks to set the scene for your cartoons. Once our brains have something recognizable to work with, they will often fill in the rest of the picture by themselves, which saves you having to draw it.

A simple skyline background, as shown above, suggests a modern cityscape.

Adjusting the skyline a little can move the city to a different continent.

Changing the background entirely makes the costume into a joke in itself.

The art of the cartoonist then is not so much in finding simple ways to draw often complicated scenes and locations, but in being able to identify the vital elements you need to include in your picture to instantly tell the reader where the action is taking place. From the flashing neon sign outside a private eye's window to the chalkboard on the wall of a classroom, one single background item can often be all it takes to communicate the necessary information to your reader.

A single background element places this cartoon character in a typical classroom setting.

Keeping things in perspective

You will learn more about perspective in the chapter on comic-strip drawing (see page 118) but at this very basic stage, there is one simple rule that will help you achieve the correct perspective in your cartoons—whatever is nearer to the viewer in your pictures will be drawn bigger and lower on the page; whatever is farther away will be drawn smaller and higher up the page. When using this method it doesn't matter what you are actually drawing; if a baby is crawling with the Taj Mahal in the background, the baby and not the building will be the biggest drawing on the page. It is important to draw it lower on the page, too, or it will look as though the famous building is being attacked by a giant baby.

Replacing the background with a new element switches the setting to a medical one.

This demonstration of "near" and "far" also shows how a flag can be used to indicate location—in this case, Paris.

Drawing from reference

Inspiration is all around you and, while imagination is one of the most important drawing tools, reference material and images that can spark your imagination and create opportunities for drawing practice are extremely valuable for the cartoonist.

must know

Because your sketches are intended to be raw material instead of finished pictures, feel free to jot down words, such as "blue sweater" or "wrinkled texture," as well as images to make sure you get all the information you need for your pictures in the time you have available.

Real models, real progress

Even in this age of Internet searching and digital databases, one of the best ways for a cartoonist to collect visual reference material is simply to carry a small sketchbook and some drawing materials wherever he or she goes. You never know when someone or something will catch your eye and provide raw material for a cartoon joke or drawing. Initially, you may feel a little nervous about sketching in public, but after a little practice you will find it becomes easier to jot down the information you need quickly. In fact, having less time to do the drawing trains your eye to edit out unnecessary details and identify the important basic shapes and most distinctive features of your chosen subject.

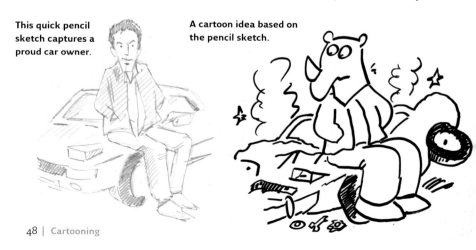

This quick pencil sketch captures a proud car owner.

A cartoon idea based on the pencil sketch.

Capturing the essence

The key factor when doing quick sketches is that you are gathering information about your subject—the pose they have adopted, what they are wearing, the principal colors visible—so that you can use this

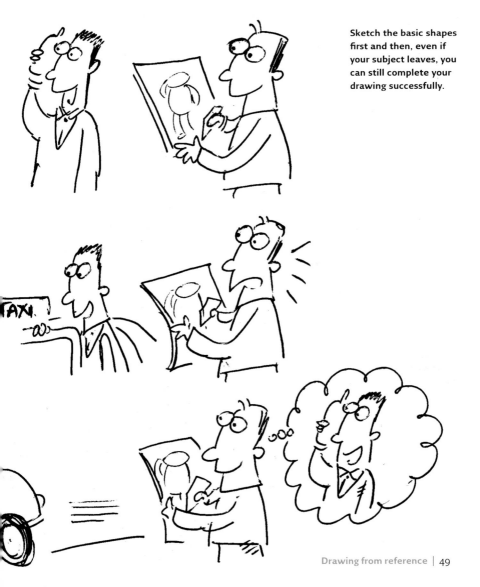

Sketch the basic shapes first and then, even if your subject leaves, you can still complete your drawing successfully.

Sketches from a sports game

detail to enhance your cartoons later. Your sketch does not have to be a work of art. However, you may find that the more sketching practice you do, the more accomplished you will be and the more polished even your rough sketches will look.

Drawing from photo references

Photography reference material can be found in a wide variety of places, both on- and offline. While libraries and Internet searching are important as aids to cartooning, many cartoonists still like to keep their own reference files of material, especially of subjects they are interested in and have to draw frequently. They also do this to preempt a very strange and frustrating phenomenon—namely, the fact that no matter how common or well known the person or object you intend to draw, as soon as you actually need to draw it all existing photos of the subject seem to disappear off the face of the earth!

Getting the silhouette of the Tower of London right was essential in order to make this historical picture work.

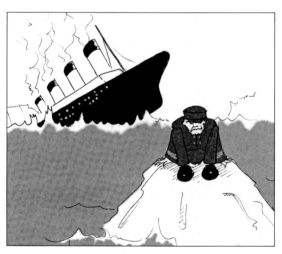

Reference pictures were used to make the sinking *Titanic* instantly recognizable in this cartoon.

Adapting reference material

While everyday items and objects have their place in the world of cartoons, the nature of the medium is that cartoonists also need to draw characters and scenes that are less easy to find reference for, be they aliens, monsters, haunted kingdoms, or space stations in far-flung galaxies. Therefore, it is useful not just to practice using reference material to make your drawings more accurate, but also to try adapting and exaggerating material that is drawn from real life as a basis for more fantastic pictures and scenarios in your cartoon versions.

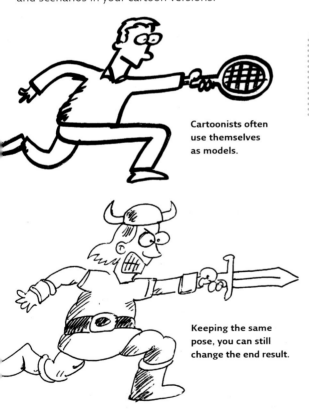

Cartoonists often use themselves as models.

Keeping the same pose, you can still change the end result.

want to know more?

• Look at your practice drawings occasionally. Seeing the progress you have made will make you practice even more.
• Animation and cartoon art are not the same, but model sheets show how reducing a character to its basic shapes makes it possible for artists to draw it accurately. You will find model sheets online at www.animwork.dk
• Check out the image search feature on www.google.com for photo references for any subject you need to draw.

5 Bringing your cartoons to life

Once you have learned to draw basic cartoon figures, the next step is to bring them to life. Animation is the most obvious way of doing this (see page 172), but long before movies were invented, cartoonists were developing special techniques to communicate sound and movement, not to mention feelings and emotions, with nothing more than paper and pen. In this chapter, you will learn to apply these techniques to your own work.

Posing your characters

The first step toward bringing your cartoon characters to life is creating a movable frame. Fortunately, this frame is one that even beginners have probably drawn many times before.

Start with a stick figure

Almost everyone can draw a simple stick figure, but don't be fooled by how easy it is. Along with the basic drawing shapes you have been using, stick-figure drawing will enable you to make your characters do almost anything you want them to.

Whenever you need to draw a character in a specific pose, start with a stick figure in light pencil in the pose you are aiming for. Don't worry if you don't get it right the first time. Draw as many stick figures as you like until you find the one that works. This is the frame on which you can build up your finished cartoon character, using the basic shapes.

To get a pose right, use a slightly more detailed version of the stick figure with jointed arms and legs (below). This becomes the basis of a more realistic super figure, in exaggerated action (far right).

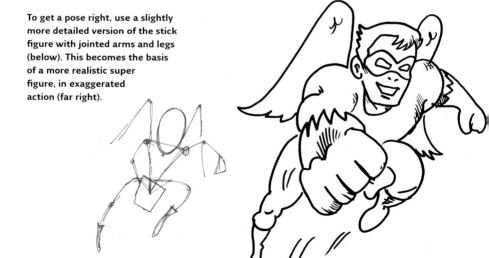

Once you have built up the detail of your finished drawing, simply erase the stick figure underneath.

From pose to pose

The beauty of being able to build up your basic shapes on top of a stick-figure frame is that for most people it is a lot easier (with a little trial and error) not only to get a stick figure to do what you want it to on paper, but also to work out which parts to change to create a new pose, instead of having to move a lot of body shapes into different positions. Once you have got your stick figure in the new pose, you can focus better on drawing in the individual shapes and details of your finished picture without having to worry about whether they will all still be in the right places in relation to each other; your stick-figure frame is there to ensure that.

Building your cartoon characters up in this way also makes it easier to keep them looking the same, no matter what pose you put them in—something that is very useful if you progress to comic-strip or animation drawing.

Use pose power

Cartoon characters live in a larger-than-life world, so when posing them for your pictures it is always a good idea to think BIG. Where possible, exaggerate your character's poses to make it very clear what action you are trying to convey. It can help to watch people in real life—try to capture their poses quickly in simple stick-figure form and then use the real-life stick figure you have drawn to build your own character on top. Once you have a finished picture you like, you can erase the construction lines.

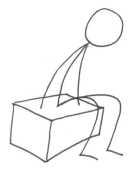

Start by drawing a basic pose, such as sitting, with a stick figure in a seated position.

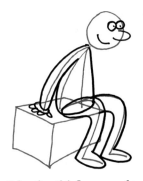

Using the stick figure as a frame to guide you, start to draw in your basic shapes.

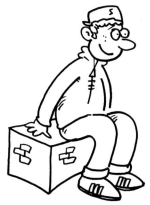

Once you have completed your drawing, erase the stick figure.

Movement

Cartoons don't have to be animated to capture a sense of movement. Some simple graphic tricks let you create the impression that your pictures are moving, even on a static page.

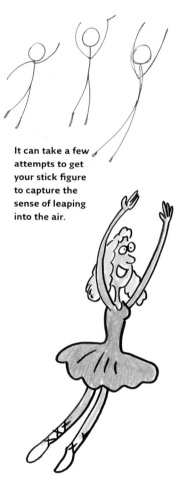

It can take a few attempts to get your stick figure to capture the sense of leaping into the air.

Once the motion is captured, however, it can form the basis for a leaping dancer.

Cartoons in motion

Once you are able to turn your cartoons from stick figures into finished characters, it becomes a very easy next step to get them to move around your pages. Stand still yourself and then start to move a little—what do you see and feel happening? It isn't just the fact that as you move different parts of your body they change position; what also happens is that the weight of your body shifts in whichever direction you are moving. It is these elements that you need to capture in your drawings in order to create that sense of motion. Once again, it can help to draw several practice stick figures until you find the one that best sums up the feeling of movement you are trying to create. You can use this figure as a base on which to build your finished drawing.

Using models

Many cartoonists use specially jointed artist's model figures, which can be purchased from most art stores, to help draw movements more accurately. Artists drawing superhero comics sometimes use action figures from a toy store to fulfill the same function. If you would like to have the same help without spending any money, you can always ask a friend or family member to model for you. Because you just want to capture the basic stick-figure form

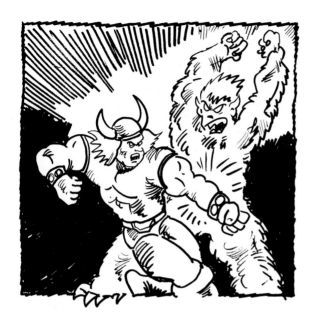

Setting up an action scene with stick figures helps get both movement poses right.

When you put in the detail you can leave out elements, such as the foreground foot, if they don't fit your frame.

of their movement, he or she should not have to stay still for too long and you can always offer a finished cartoon original as a reward.

Exaggeration

Building your shapes on a stick-figure frame helps keep your character looking basically the same, even when you draw it making different movements. The skeleton is there to hold everything together, so you can exaggerate and stretch your character to make its movements more extreme. Add to the sense of movement with clothes, such as hats, scarves, and cloaks, which fly off or trail behind as the character leaps into action. Feel free to exaggerate the effects of motion on clothes and props. A technique often used is to make the movements as extreme as possible until they no longer look viable. Move back a step and you have your ideal movement picture.

Faces and emotions

To create characters with personality, portraying emotions is very important. Observing faces helps you develop a range of expressions. Just subtle changes in features can create different emotions.

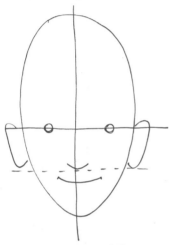

You can create many different faces from a basic face template, but most faces have features in the standard places shown here.

Facing facts

There are many different kinds of cartoon face, ranging from the very simple big-eye style of drawing to the highly detailed and realistic faces in graphic novels. Of course, many of the most famous comic characters wear masks over their faces so you don't see them, but even then it is essential for the artist to be able to use the features that are visible to show a range of emotions. As with cartoon characters' bodies, it is also important that once you have created a character, the face remains recognizably the same, no matter how many different expressions it may adopt or what angle we see it from.

As you have already learneed with your characters' bodies, constructing their faces from a standard model is the best way to ensure you maintain that vital recognition factor later on.

The basic face shape

For most artists, not just cartoonists, there are a few surprises in store when you start to look at a basic face shape. Most of us, when asked to indicate where the eyes would be, tend to draw the line too high up—in fact, on the vast majority of faces, the eye line falls exactly in the center of the head shape. Similarly, knowing that the tips of the ears and the

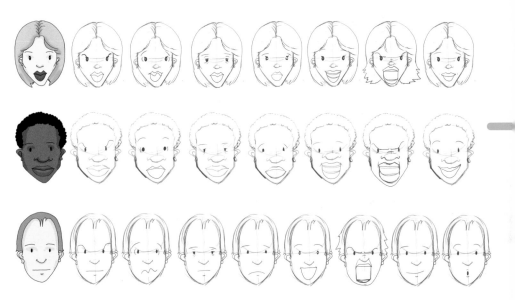

top of the nose are along the same basic line as are the top lip and the bottom of the ears means that even the most square-jawed superhero face can be built on a realistic model.

Even for manga-style characters or extremely cartoonish faces, it is good to have an idea of how faces are actually put together, so that when you do redesign or exaggerate them you will be doing it deliberately instead of by accident.

Faces everywhere

One of the fun things about cartooning is that your characters don't have to be human, or even living creatures, to give them faces and personalities. Almost any object can be brought to life by adding eyes and a mouth to any available surface.

Using light guidelines to position the features of each face means you can change the expression but it still looks like the same person.

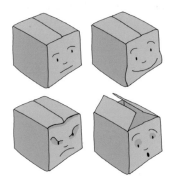

With the addition of a simple face and expression, even an inanimate object, such as this box, can take on a personality.

Expressing yourself

If you like to send e-mails from your computer, you
will be familiar with how many different emotions
can be made with very simple "smiley"-type faces.
Just as you can use stick figures to build up more
detailed movements and poses, you can also
experiment with creating emotions on the simplest
of faces. When you have hit on the arrangement
of eyes and mouth that best conveys the particular
emotion you are aiming for, you can use your
simple "smiley" face as a guide to drawing your
more detailed version.

Exaggerating emotions

As with their dramatic poses and movements,
cartoon characters are rarely shy about how they
are feeling. Exaggerating the normal expressions

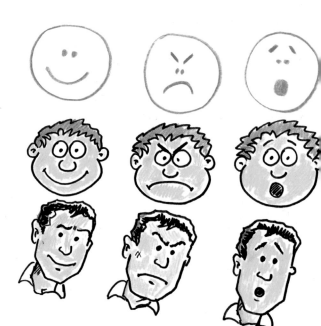

Once you have captured an
expression in "smiley" form,
the same one will work well
for both simple and more
realistic cartoon faces (right).

someone in real life would make when experiencing a particular emotion will usually give you just the right volume for your cartoon characters when they are feeling the same way.

Exploring emotions

There are two ways to expand your repertoire of cartoon emotions for future use. The first is to think of a number of different emotions, ranging from the basic ones, such as anger, happiness, or fear, to more subtle ones, such as worry or embarrassment.

Now you can set yourself the task of conveying those emotions on as many different cartoon faces as possible. Another way to practice this is simply to draw a lot of faces with different expressions at random. Next, ask yourself how that particular character might be feeling based on whatever expression you have drawn.

Once you decide on the emotion being expressed, make a note of how you achieved it. Was it the eyes or the mouth or a combination of both? Whenever you are called upon in the future to show a different character expressing those same feelings, you will know just what to do to achieve the same effect.

Human emotions can also work for cartoon animal faces.

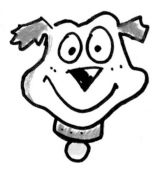
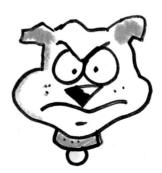

Body language

Drawing creates your characters on the outside, whereas body language shows how they feel on the inside. The more you look at real people, the more body-language styles you can reproduce.

Your inner actor

Someone once said that inside every cartoonist is a cartoon character waiting to get out. It's certainly true that many cartoonists design characters that look a little like cartoon versions of themselves, but it can also be useful to reverse that process and try to act out what your characters will be doing before working on the finished picture. Facial expressions are important for conveying emotions and feelings, but in acting out what the character you are about to draw will be doing, you will find that overall body language also plays a part in making the drama more dramatic and comedy funnier.

In this surrender pose, it's the character's hands that do the work.

The face and the arms are working together in this picture to suggest anger.

Talking hands

Hand gestures are a useful way of emphasizing what a character is trying to communicate. This is even more the case with cartoon characters than other kinds of drawing—remember that it is very common to draw cartoon hands and feet a bit bigger than they would normally be. This makes "stop" and "fist-waving" gestures particularly expressive.

Mind that body

Being aware of body language can help you avoid a common mistake in cartoons, where more than one character is doing the same thing. It is easy to fall into the trap of simply drawing each character in a picture in very similar poses. Unless you are aiming for a duplication effect, this can make your drawings look very unexciting. Conversely, being aware that although we may all do the same things, we don't necessarily do them in the same way, helps add variety and visual interest to your work.

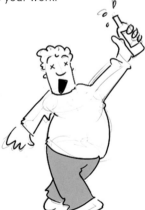

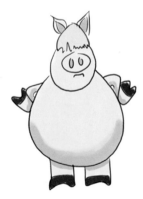

Here is a very distinctive way of walking, both boldly and purposefully.

Even without the bottle, it is obvious that this character's walk is unsteady.

Human body language can help to convey anger, even in a pig, as illustrated here.

Bringing animals to life

Animal characteristics can add interest to your pictures, even when you are drawing people. Cartoony or realistic, the level of detail you choose for animals in motion is up to you.

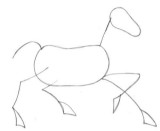

A complicated animal, such as a horse, is easier to put in motion if you start with a stick picture.

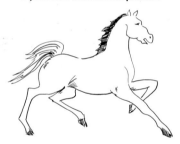

Use your stick figure as the basis of a realistic finished drawing.

You can exaggerate the features of your stick animal to make the end result more cartoon styled.

Starting with stick figures

The same stick-figure approach that you have been using to pose and move human characters around can also work for animal drawings. Of course, since you are in possession of a human instead of an animal body, you may need to take a close look at the characteristic poses and movements of the animal you are drawing before you translate them into stick-figure poses.

Once you have your basic stick-figure frame, you can begin to add the shapes that will create your finished animal. Even when you are drawing an animal covered with hair or fur, having a working frame beneath your drawing will make the poses and movement a lot more realistic.

Anthromorphic adventures

You can have a lot of fun drawing anthropomorphic animals simply by using a human stick figure and then building the animal body on top of it. However, keep in mind the specific animal you are drawing, and also think about any animal characteristics they might bring to the pose or action they're doing that an ordinary human couldn't. You might be surprised at how many artists, who are known for cartoonish animals, still make a habit of regular sketching visits to the local zoo or natural history museum.

Animal powered people

Many superhero characters draw their powers from the animal kingdom. If you create a character of your own with animal abilities, make sure that their poses and movements reflect the animal side of their nature as well as their human one.

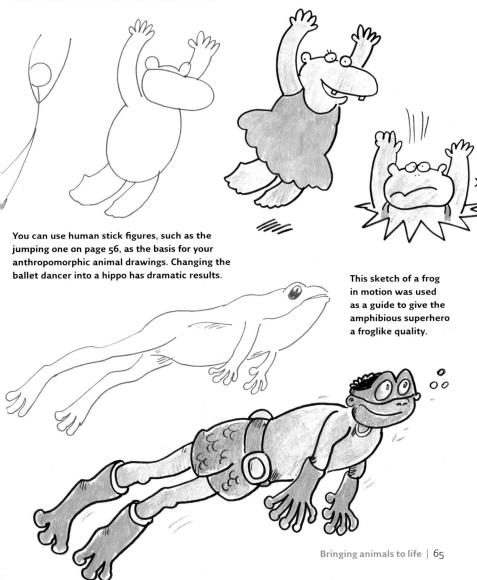

You can use human stick figures, such as the jumping one on page 56, as the basis for your anthropomorphic animal drawings. Changing the ballet dancer into a hippo has dramatic results.

This sketch of a frog in motion was used as a guide to give the amphibious superhero a froglike quality.

Special effects

Cartoonists have developed a wide range of symbols and special effects that you can use to add even more life to your drawings. Trying the standard ones may give you ideas for your own.

The vibration lines drawn on either side of this tuning fork make it appear to resonate.

Enhancing the action

The more you practice, the livelier your cartoons will be, but you don't have to rely solely on drawing skills to inject movement and life into cartoons. Visual symbols and special effects can enhance the sense of speed and motion you are trying to create.

Transformation scenes can be made even more dramatic by showing all the stages in just one single picture.

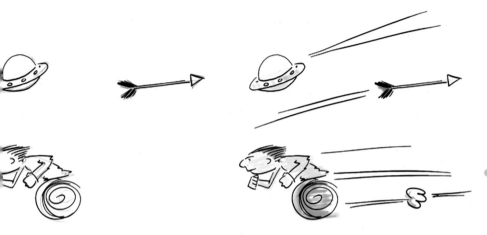

Experiment to get it right

From speed lines to vibration marks, you can add a little or a lot of these special effects, depending on how dramatic or subtle you want them to be. It can be helpful to experiment by adding these effects in pencil at first, so that you can try out different ideas and approaches until you find just the right effect you are looking for. Don't worry if your first attempt does not achieve the end result you wanted—just erase your pencil lines and try again.

Both human and mechanical speed can be enhanced by adding speed lines. The person running is further speeded up by making the legs a blurred wheel.

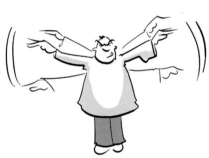

Duplicating the arms in this illustration creates the effect of frenetic motion.

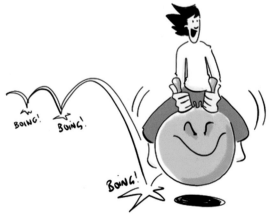

The bounce effect in this picture is enhanced by adding some vibration lines around the knees.

Enhancing emotions

Just as we can turn up the volume on movement and action in our cartoons by using extra effects and symbols, there are also many widely recognized ways of adding to the emotions of your characters that you are trying to convey in your drawings.

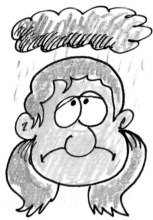

Unhappiness can be made more miserable by adding a dark cloud.

Using symbols

From a few simple sweat marks to show worry to clouds and lightening bolts to denote rage or extreme sadness, some of the most widely used symbols for emotions in cartoons are as pictorial as the drawings they are used to enhance.

Creating your own effects

Whenever you see a cartoon symbol or effect that strikes you as clever or useful, make a note of it so that you can use it in your own work. But don't be afraid to experiment with creating your own effects, too; it might be that in years to come cartoonists who want to show a certain movement or emotion will do so using some of the symbols and effects you have added to the cartoonist's visual toolbox.

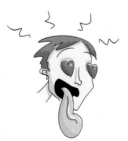

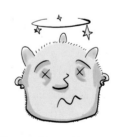

Currency signs in the eyes will denote to the reader a love (or expectation) of money.

Replacing the eyes with hearts makes love even more passionate.

Stars, swirls, and lumps on the head convey the message that it's a knockout.

Speech balloons

Not only can you make your cartoons move but you can also make them "talk" by using speech balloons. In this case, one picture really can take the place of a thousand words.

Talking pictures

The idea of using speech balloons (also called speech bubbles) to convey what your characters need to say is almost as old as cartoon drawing itself. Over the years, cartoonists have developed a wide variety of different types of speech balloons to communicate not just words, but also different levels of volume and tones of voice.

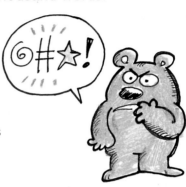

These symbols stand in for words that cannot be printed (and are probably worse in the imagination than they could ever be in real life).

If you have a lot of words to fit in, a balloon with straighter edges sometimes works better.

Jagged edges around a speech balloon are for shouting.

Your speech balloons and the words inside them can either be drawn by hand or you can draw blank balloons and then typeset the text to be pasted in at a later date. However you choose to make your speech balloons, make sure that the words inside are always clear and legible.

Round speech balloons are a common way of showing normal speech. Long speeches can be broken up into several balloons.

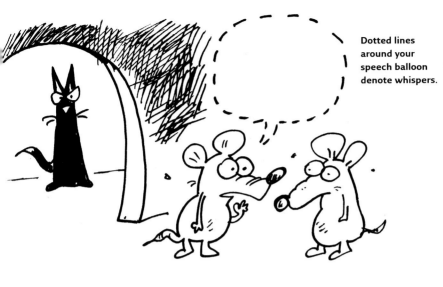

Dotted lines around your speech balloon denote whispers.

Thought balloons have a more cloudlike quality and can be used to show thoughts in both words and pictures.

want to know more?

• Eadweard Muybridge (1830–1904) is the key inspiration for learning to draw people and animals in motion. His photo collections *Animals in Motion* and *Humans in Motion* (published by Dover) are still used as reference by artists all over the world. Some of his sequences are online at California State University World Images Database http://worldart.sjsu.edu

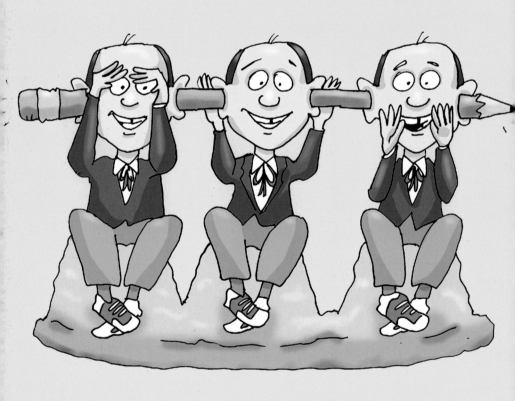

6 Cartoon humor

Cartoons are much more than just funny *looking* pictures. They usually contain funny jokes, too. For many beginner cartoonists, having to come up with the jokes is even scarier than having to draw them. In this chapter, you will learn that just like drawing, a wide range of jokes can be created simply by following a few basic steps.

Where do funny ideas come from?

Creating humor involves serious brainwork. Perhaps the biggest joke about our sense of humor is that, although there have been many studies and theories down through the years, nobody knows for sure why we have one and what its purpose is.

must know

Sense of humor is different from person to person. Just because you think something is funny doesn't mean that your reader or editor will, and vice versa. The only way to check for sure is to draw your cartoon and find out.

Brain strain

We do know that happiness is healthy and that laughter makes us feel good, but, if you have ever tried to force yourself to laugh, you will know that it's one of the hardest emotions to switch on at will, which is what can make life hard for cartoonists and comedians whose job is to do precisely that.

Having to create something funny on a blank sheet of paper is a daunting task, no matter how experienced the cartoonist.

Tricks and techniques

Fortunately, humorists have come up with some useful tricks and formulas that seem to be very effective at generating laughter, and once you are aware of these techniques and start to include the ideas in your cartoons, it will become much easier to devise jokes that work.

The most basic trigger for laughter seems to be the fact that our brains, while they are very complex natural computers, seem to have great difficulty holding two unrelated ideas at the same time.

For this reason, some of the most common laughter-making techniques that cartoonists use in their work is to combine ideas and pictures that usually don't go together—for instance, treating a serious topic in a funny way or pointing out how one picture or word looks or sounds like an entirely different picture or word. When our brain comes across an unexpected combination, its response seems to be surprise and confusion—a sensation that seems to express itself as laughter.

The brain has difficulty juggling two different concepts at once, which results in comedy ideas.

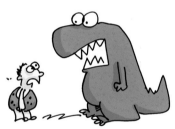

A scary dinosaur and a scared caveman is something that we would expect to see.

Seeing the same two characters in this setting is unexpected and much more likely to raise a smile.

Just as doodles loosen up your drawing skills, getting random ideas down on your blank sheet of paper will make it less scary and spark more new ideas.

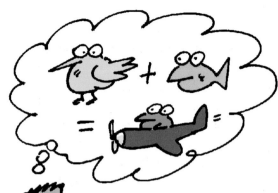

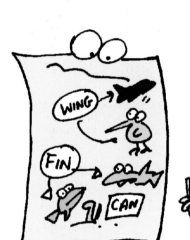

Generating ideas

Now that you know the building blocks of humor are ideas—not necessarily funny ideas but just ideas—your aim should be to generate as many ideas as possible for each cartoon you are aiming to draw. The more ideas you come up with, the more options you will have to combine them in different ways. When you generate enough ideas and combinations, it increases your chances of hitting on those connections that will lead to laughter.

Don't worry if at first it takes time to come up with a number of ideas—like all exercise, whether we are using our brain or some other part of our body, it takes practice to build up your idea muscles.

Combining ideas

It doesn't matter either if, when you start combining ideas, many of the combinations are so weird that they don't make any sense at all. Simply make it a habit to experiment with joke production regularly

in the same way that you have been doing with your drawing exercises and you will soon find producing humor becomes easier and faster.

In the rest of this chapter, you will see some of the most common types of cartoon jokes. Try coming up with your own versions of each joke—not only will it help you understand the underlying machinery that makes each type of joke work, but you will also find that adding your own drawing style and ideas to the basic humor leads to jokes that are not only equally funny but unique to your own cartooning talent and sense of humor.

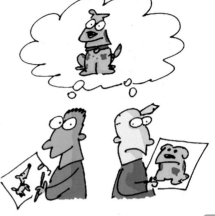

Even if two cartoonists have the same basic idea, individual style makes the end result different.

Humorous ideas for drawings can be sparked by other cartoons, wherever you can find them.

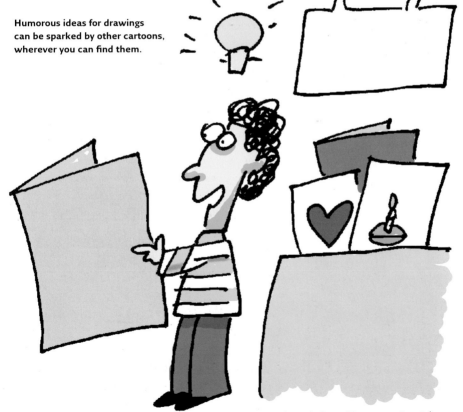

Putting puns to work

Word play can be important in creating jokes. The pun—a joke based on one word sounding like another—is often described as the lowest form of wit, but if this really is the case, some very respected cartoonists and successful cartoon brands, such as *The Far Side*, regularly elevate it to a very high level indeed.

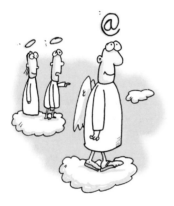

Elements, such as the halo on this Internet angel, can be changed to a pizza, bowling ball, or other activity, depending on the joke.

Sound-alike words and phrases

Because connecting two unusual ideas is a building block of comedy, it is easy to see how linking two words or phrases that are alike in terms of their sound, but that mean two very different things, is exactly the kind of juxtaposition that will probably result in surprise and laughter.

Developing the idea

You can take this idea one step further by linking a seemingly innocent phrase to a picture that completely changes the meaning. This technique is often used by cartoonists not only as a way of

The phrase "fire escape" is given a more literal meaning here.

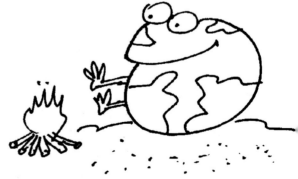

As new terms, such as global warming, are added to our vocabulary, they also become the source of new cartoons.

This cartoon is one interpretation of the old saying that "a stitch in time saves nine."

Since a "stitch" can also represent a pain incurred while running, here is another version.

filling their day-to-day joke quota but also to come up with some very surreal and memorable jokes.

In the same way that cartoonists are constantly searching for sound-alike words and phrases that can be turned into puns, you should also keep your eyes open for any visual images and symbols that could be matched to other pictures, because purely visual puns - such as the '@' symbol halo - are particularly popular, especially if you would like your work to be viewed overseas where other languages are spoken.

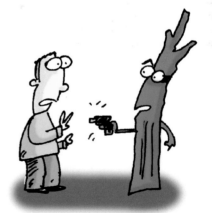

"It's a stickup" might be drawn this way...but only if the term "stickup" means a mugging to both artist and reader.

Character comedy

In cartoon comedy, just as in television and movies, it can seem as though much of the humor comes from creating funny situations. However, a closer look often shows that it is the way in which your characters react to what is happening that really generates the laughs, whatever is going on around them.

Making stereotypes work

Since a single cartoon has so much information to get across in one picture as well as a short caption, it is not surprising that many cartoonists often rely on character stereotypes, which are often not just exaggerated but sometimes don't actually exist outside of cartoons and old movies. For instance, not every French person wears a striped shirt and beret and carries onions, but this image is still often used in cartoons. Similarly, the modern film director

Having a character act the opposite of how we expect, such as Santa Claus being scared of children, can also generate humor.

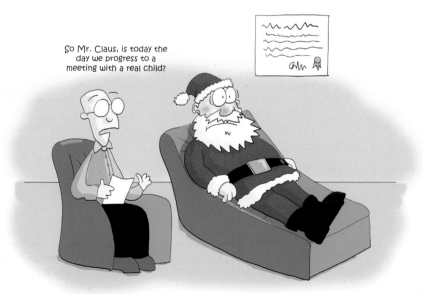

So Mr. Claus, is today the day we progress to a meeting with a real child?

is much more likely to use a cell phone than a megaphone to communicate with his cast and crew, but the old-fashion image is much more fun and recognizable to draw, so you will still find cartoonists using it.

How characters act

How stereotypical cartoon characters behave and dress is not just useful in having readers of your cartoons recognize them instantly—having them act based on their stereotyped characteristics in every circumstance can generate humor easily. A variation on this technique is to have them act in exactly the opposite way to the one that their appearance or occupation might normally suggest.

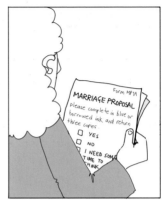

In this variation on the theme, the joke here is that government officials turn a marriage proposal into a form-filling exercise.

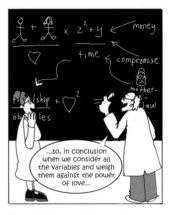

Here, the cartoonist uses the idea that scientists would approach marriage proposals from a mathematical viewpoint.

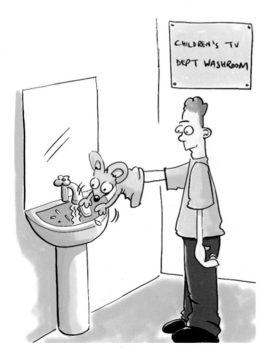

Even simple hand washing can be done in a unique way that reflects a character's personality, as in the case of this puppeteer.

Using existing characters

Famous can equal funny, so basing your cartoons on the known characteristics of the people in them will help to set up jokes. In order for those jokes to work properly, however, the cartoonist needs to be sure that the reader will know enough about the character to understand the reference.

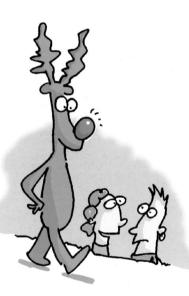

Making jokes

It is no surprise that any characters who already have a high recognition factor, whether they are drawn from history, fairy tales, legend, or popular fiction, will probably be extremely popular subjects for cartoon humor. From a visual point of view, it is even more helpful if the character you choose has a distinctive appearance or costume to go with their well-known background story.

Some of the most useful characters to use in humor are the ones who are so well-known that you can make jokes about incidents in their life or story (such as George Washington chopping down a

"Green is the new red," says the fashion expert—Rudolf is so well known his name isn't needed.

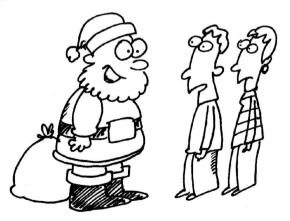

Santa, being one of the most famous characters of all, can be linked to any topic. Two hassled parents want the Christmas present of being able to hide in his sack until December 31.

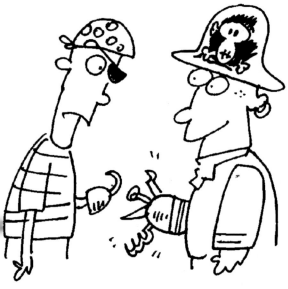

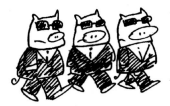

Mister Straw, Mister Wood, and Mister Brick are the Reservoir Pigs, but the image will only make sense to those people who know the iconic movie poster.

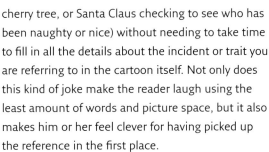

The success of the *Pirates of the Caribbean* movies has made pirate jokes popular again in the cartoon world. This pirate has a Swiss army knife-style hook.

cherry tree, or Santa Claus checking to see who has been naughty or nice) without needing to take time to fill in all the details about the incident or trait you are referring to in the cartoon itself. Not only does this kind of joke make the reader laugh using the least amount of words and picture space, but it also makes him or her feel clever for having picked up the reference in the first place.

Reference recognition

It should go without saying that to make this kind of joke work, you need to be confident that most readers actually know enough about the character and their story or catchphrases to recognize the reference. For instance, the popular joke about Darth Vader knowing what Luke Skywalker is getting for Christmas because "he felt his presents," only works if you know that "I felt your presence" is a line from the original *Star Wars* movie.

Although the legend of Icarus may not be known by everyone, the early attempt to fly is visual enough that even non-historians will still get the joke.

Look behind you!

What your characters don't know can help you. When it comes to character comedy, whether it is in a television comedy, a movie or a cartoon, there are two basic types of funny character.

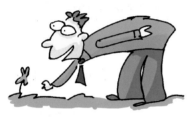

This four-leaf clover is about to prove very unlucky indeed for the unsuspecting finder.

Funny characters

The first type is the character who is deliberately funny, whether by constantly making wisecracks or by doing crazy things. A much more common comedy character is the one who is not deliberately trying to be funny but, nevertheless, who keeps finding himself in comical or unusual situations. Often it is the extreme seriousness with which the character approaches the most ridiculous things that generates the laughs in the reader.

In the single panel cartoons you are practicing in this chapter, one very easy way of creating humor is

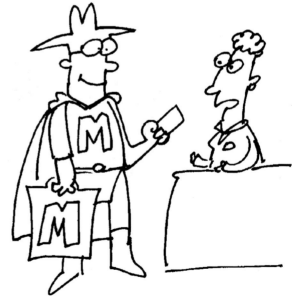

The original caption to this picture was "Are you by any chance the Mystery Shopper?" Not only is it unlikely that a mystery shopper would dress in this way in real life, but it is also unlikely that the question would need to be asked.

simply to have something happen—or be about to happen—which the reader knows about, but that one or all of the characters in the cartoon are not aware of.

The power of exaggeration

Of course, since the cartoon world is, by definition, exaggerated it is perfectly normal for the unexpected or hidden person, object, or event to be so big or obvious that nobody in real life could possibly miss it. In fact, since exaggeration is also a very effective comedy tool, the more unlikely the situation, the funnier the resulting cartoon often is.

Not only is the diver unaware of the danger, but there is also a sense of getting his just desserts, which adds to the comedy.

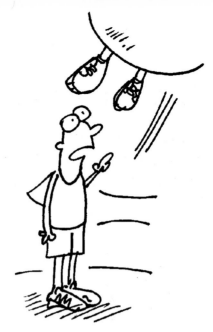

In cartoons like this, where a marathon runner dressed as an air balloon has actually taken off, leaving some of the picture out makes the reader create a funnier picture in their imagination.

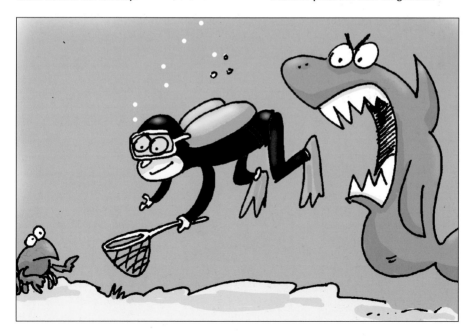

Working with words and pictures

Achieving the right combination is the key to success. At first glance, it may appear that combining the words and pictures in cartoons is an easy task—after all, if the pictures are funny and the words are funny, surely putting the two together should make the result doubly funny, or does it?

Combining words and pictures

It is certainly true that many cartoonists are as witty with words as they are with pictures, but if you think of some of your favorite verbal jokes, you will note that not all of them would work as well with pictures added. Similarly, you may well have come across some cartoons in the past that made you laugh, but when you tried to describe them to friends who haven't seen them, the jokes don't seem to get the same reaction.

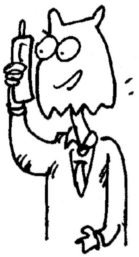

The caption "Hi, I'm an anonymous caller" becomes funny thanks to the bag on the caller's head.

In this overseas recruitment cartoon, the appeal for "Chefs in Congo" has been confused with one for "Chefs to Conga."

Putting captions and pictures together to get the right comedy effect takes practice—leave too much out and the joke does not make any sense, but put in too many words, or make the drawing too complicated, and the comedy can also be diluted and sometimes lost altogether.

Word-based humor

One point to be aware of when using jokes that rely for their effectiveness on word and picture combinations is that since word-based humor is often based on the sound and meaning of words, the joke may not work at all when the cartoon is translated into a different language, although the cartoon drawing will not change at all.

Book covers allow endless word and picture jokes. This one might read *The A-Z Guide to A-Z Guides*.

The joke in this news cartoon is not clear if you don't know that the caption referred to a garlic bread shortage.

Catchphrases and sayings lend themselves to word and picture jokes. Here, Shakespeare wonders which pencil he should use—a 2B or not a 2B.

Classic cartoon themes

What goes around comes around, often funnier than ever. Given that thousands of drawings have been done and an equally vast number of jokes have been made, all based on the building blocks discussed in this book, it shouldn't be a surprise that many common themes and subjects turn up over and over again.

Producing new ideas

What might be much more surprising is that even the most familiar themes can still be made fresh and funny when cartoonists come up with new variations. In fact, it is a very useful ideas-producing technique to take a little time to consider whether or not the cartoon subject you may currently be struggling with might somehow be fitted into one of the classic cartoon situations shown here.

Just like desert island castaways, cartoon captives are often optimistic: "Should we stay in or go out tonight?"

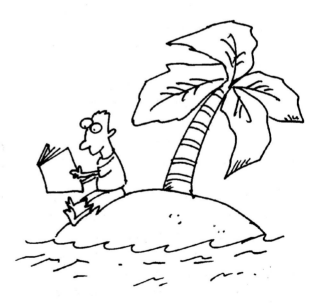

Because desert island cartoons often rely on castaways making the best of things, the book title could be *Places to Eat Out*.

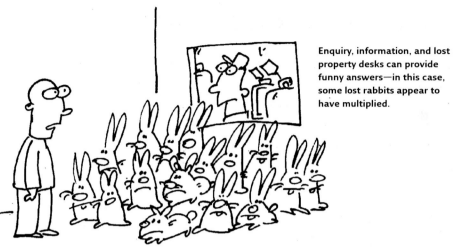

Enquiry, information, and lost property desks can provide funny answers—in this case, some lost rabbits appear to have multiplied.

Recognizable themes

Some favorite cartoon themes are automatically recognizable because they involve fantasy situations, such as being marooned on a desert island or meeting space aliens, but the kind of cartoons that find humor in mundane everyday settings, such as in the home or office, or in the day-to-day frustrations of life itself, work well, too, and in many cases derive their comedy from the same basic triggers.

If you look back over your own favorite cartoon collections, you may find several examples of the subjects and settings that are featured in this section, but you will probably also find some other recurring themes.

Many classic cartoon situations are very good demonstrations of an aspect of the cartoon art form that sets it apart from many other visual styles. Cartoons have the ability to extract humor from and poke fun at what would usually be seen as very serious, unpleasant, and even traumatic events.

Cartoon psychiatrists often have to deal with all sorts of exaggerated conditions—in this case, extreme insecurity.

Having very young babies discuss traditionally adult issues, ranging from relationships to world affairs, is a popular approach.

Alien observers allow cartoonists to make their own comments on life on the earth.

Cartoon characters are often found delivering their funny lines while chained up in dungeons or telling the psychiatrist about hang ups and obsessions, which, if they were presented in a more dramatic fashion, could easily be scary or even depressing.

The influence of technology

As with all fashions, the types of theme that recur in cartoons at any given time are often influenced by what is topical or going on in the news and current affairs world at the same time. Subjects and themes can also fall out of favor as time marches onward and people's tastes change. The popularity of new forms of technology will always lend itself to cartoon ideas.

As a piece of new technology gets older or more commonplace or a news item becomes yesterday's

Business charts have been used to make countless cartoon comments on profits, although not always encouraging ones!

news, they may be replaced as a hot topic by the next big thing. However, since cartoonists enjoy historical subjects and themes so much, that is no guarantee that the gadget or news event will not eventually join the ranks of the classic cartoon themes and, like the ones discussed here, be repeated with some new variations over and over again.

Cartoon gurus often dispense wisdom, or they just ask about the football scores.

Explorers in cooking pots are an example of a once widespread theme that is now considered very politically incorrect.

Variations on a theme

One good cartoon can lead to many others, and while it is never a good idea to copy another artist's work (unless it is for learning purposes and you don't intend to pass it off as your own) someone else's cartoon or even a previous cartoon you have done yourself can easily be a jumping off point for original ideas of your own.

Utilizing themes

In the illustration shown below, the original cartoon has inspired a number of other jokes—some similar, and others different. Here are some useful questions to ask yourself, so you can use existing cartoons to create new variations of your own.

"Close your eyes, there's something scary on the television."

What other jokes can I do in the same setting?
In this example, the joke is centered on an everyday domestic appliance—the television—as well as a particular phrase used in relation to it: "on the television." This can mean two things: a program that is broadcast or, as in the

cartoon, something or someone being physically on top of the set. What other domestic appliances along with phrases associated with them could be used to make similar jokes?

Would the joke work in a different setting?

Where else might you find a television? Where else do parents shield children's eyes from frightening things? Because you are aiming to produce a joke, what are the most unexpected locations where these things might happen? How would putting a different character or topic in this setting change the joke? A parent might object to scary or violent television, but what character might enjoy it? What might happen to that character as a result?

Asking questions like these can be a particularly useful technique if you aim to submit cartoons for a particular publication or a specific audience that may already have its own distinctive likes and dislikes. Doing some detective work on existing cartoons in that market can be helpful in hitting on what will and won't work when it comes to your own cartoons.

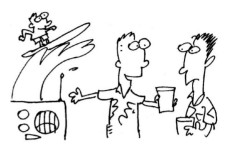

Substituting radio for television, this character shows off his "short wave" radio—complete with miniature surfer.

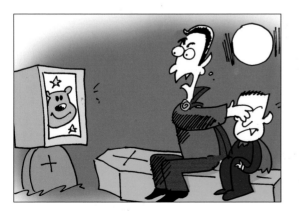

Changing the characters to vampires means the joke can become "Close your eyes there's nothing scary on the television."

Choosing the best idea

Cartooning is not an exact science. The first point to make about choosing the best joke is that there is almost never agreement among cartoonists, publishers, or audiences on what the best joke actually is. The one that works for *you* is usually best.

A new story about a cobra guarding a department store's prize ring led to this idea of a security guard who has detected a "hood," but it only works if you know that "hood" is a euphemism for crook.

Making your final choice

Everyone has a different sense of humor and what one person finds hilarious can often create no reaction in another person. In this chapter, you have been encouraged to start off by coming up with as many different ideas as possible for each cartoon you are aiming to produce. Many of these ideas will not actually qualify as jokes at all, but usually if you work hard at turning out ideas you will end up with several that do work as jokes or, at least, can be turned into jokes with a little tweaking. If you are drawing the cartoon for a specific purpose

This lady doesn't want the ring—just the cobra because it will match her snakeskin shoes. This cartoon, because it works by itself, would be the best choice here.

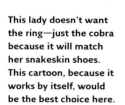

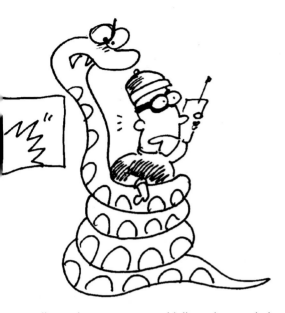

This crook has missed the jewellery department and has ended in gift wrapping, but you would need to know the news story to get the joke.

or audience, here are some guidelines that can help you to make your final choice.

Do you need more information?
What extra information does the reader need to know to get the joke? Even if your cartoon is based on a well-known character or current news story, the best cartoons are the ones that make sense from the picture and caption alone.

Which idea is simplest?
In both drawings and captions, cartoonists aim to communicate their jokes with the least amount of clutter—the joke that can be summed up in a few lines and a short caption is often the best one.

Which cartoon makes you laugh?
Because humor is so subjective, this is the only guaranteed way to be sure that your work appeals to at least one person.

want to know more?

• There are several vast sites of humor, visual and written down, on the Web. A good place to start researching is: www.aha.com
• Ron Coleman, a cartoonist with over 40 years experience, has written a good guide to magazine cartooning with the emphasis on jokes, and even an online gag writing tool www.magazine-cartooning.com

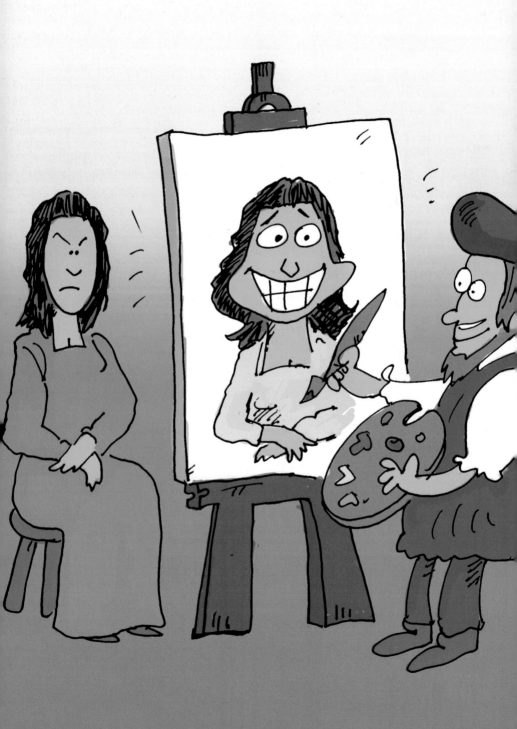

7 Caricature

Caricature may be one of the oldest forms
of cartooning, but it is also a much respected
(and sometimes feared) art form in its own
right. Whether you are working from a live
model or from a photograph, whether you are
drawing a famous person or a family member,
this is one of the cartoon skills that will most
impress your audience.

Making fun of famous faces

The easiest likenesses are larger-than-life famous people. Indeed, the art of caricature at its best is not just about capturing a person's physical likeness but also about portraying their personality.

Public versus private personas

Famous people, both dead and alive, are some of the most popular subjects for caricature. In many such cases, their public personality may be very different from their private lives, and in some instances the personality we believe them to have has been created for them, often by other cartoonists and comedians, whether they like it or not. But real or imagined, it is this larger-than-life quality that makes for such interesting drawings.

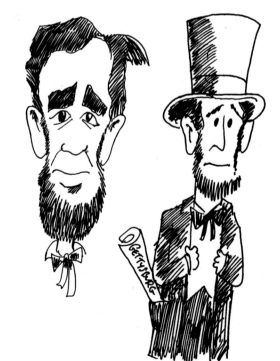

Although Abraham Lincoln (right) is a famous historical figure, his face alone may not be known to all. His distinctive dress (far right) is a more recognizable drawing even with a less detailed face.

Drawing famous faces is, of course, a double-edge sword for the beginner at caricature. The fact that the person's face is so well-known (as opposed to a friend or relation who may be known to only a few people besides yourself) means that there is a bit more pressure to get a good likeness. After all, if you draw a very recognizable face and nobody to whom you show the picture can recognize the celebrity, it will probably be embarrassing.

Raising the recognition factor

The big advantage of choosing a famous person for your caricature training is, as already noted above, the fact that so many famous faces have well-known stories and personality traits already locked into the public perception. You can add references to these extra elements to your pictures to boost the recognition factor and ensure that the success of your picture is not based on drawing skills alone.

Easy to recognize, hard to draw?

A basic truth that every caricaturist has to face up to is that some people are easier to draw than others. Glasses, beards, scars, shaven heads, or any other distinctive features you can identify are bound to make your picture more fun to draw, as well as give additional clues to your audience about who you are portraying. Many famous people also have particularly distinctive styles of dress; actors who are associated with particular movie roles are a good example. In some cases, the distinctive visual appearance, catchphrases, and other clues to those roles are recognizable even if you've never seen the movies or television shows they are derived from.

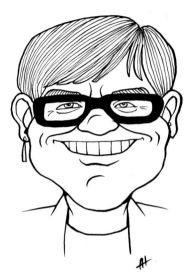

Elton John's distinctive glasses are a factor in identifying him.

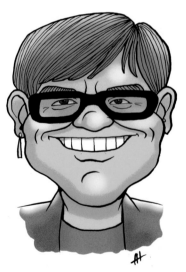

Elton's flamboyant personality means bright colors not only decorate but help to further identify this picture.

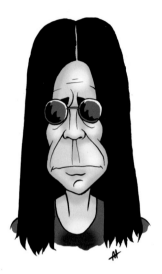

Ozzie Osbourne's hair and glasses in themselves define his look.

With a star like Madonna (right), who constantly changes her image, the right expression is often a key to recognition.

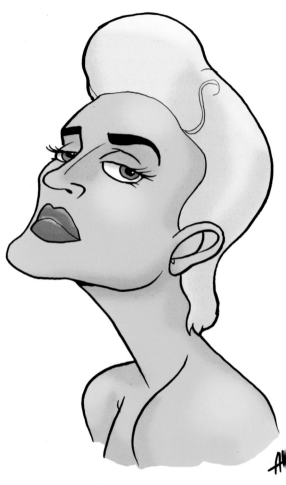

Simon Cowell's expression makes this caricature work as much as any physical details.

New-found fame

A big challenge for news caricaturists in particular is presented when somebody, such as a newly elected politician or a company director involved in a scandal, suddenly enters the news arena. Although their names and actions may instantly become talking points, it can take longer for their distinctive image to become widely recognizable; it may also be the case that in their appearance there is nothing

particularly striking about them. What often tends to happen is that cartoonists will experiment with capturing the right look, and then when someone finally gets it, many other cartoonists will base their own pictures on emphasizing the same physical features, although they may adapt the basic cartoon into their own individual style.

Even if a popular caricature subject remains in the public eye for some time and changes their hairdos, dress styles, or other aspects of their real appearance as the years advance, their standard caricature often retains the same look as it has always done. It could even be argued that, like dogs and their owners, some celebrities become more and more like their caricatures as time goes on, instead of the other way around.

must know

Whether you are drawing a famous person or a friend, try to get several different photos to work from if you can. Often one particular angle will be more distinctive and interesting to draw than the others.

Comedians and impressionists

If you are struggling with trying to capture a new celebrity or political figure, it may be some small consolation to know that another branch of the humour profession is likely to be experiencing similar difficulties: comedians and impressionists. Just as one cartoonist can learn the way another cartonnist identifies suitable traits for caricature, it can also be a good idea to keep an eye on topical comedy and political shows on television. Voice artists train themselves to listen very carefully to their subject's rhythms of speech and to home in on particular phrases and verbal tics they use over and over. You can often make use of these same catchphrases and mannerisms to add into your pictures as speech balloons to increase the recognition factor.

Step-by-step caricature

First comes correct, then comes comedy. Just as jazz musicians have to know the right notes to play before they can start to improvise on a song, the best starting point for any caricaturist is to get familiar with the basic proportions of the face.

must know

Because the facial construction guidelines are rules of thumb, it is best to sketch them in pencil so they can be erased once you have constructed your finished drawing.

Position and proportion

Although caricature works because every face has something unique and identifiable about it, the underlying construction of most faces follows some very constant rules. When you are trying to achieve a likeness of someone, whether you are drawing them seriously or aiming to exaggerate, it is not so much drawing the individual facial features, such as eyes, noses, and ears, correctly that will lead to recognition, but being able to correctly position those features in the right proportion to one another.

Keeping your distances

As you can see from the basic face shown opposite, there are a number of common factors that can help you position features correctly, no matter who you are drawing. For example, the line drawn across the face halfway down the head tells you where to position the tops of the eyes. The distance between the eyes is usually equivalent to a third "eye," while the distance from the brow to the bottom of the nose is normally equal to the difference from the bottom of the nose to the chin. The ends of the mouth are beneath each eye. The more you practice drawing faces the more chances you will have to try these guidelines and discover even more yourself.

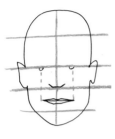

Always start from a basic shape for your subject's face, with as many guidelines as you feel that you will need.

The basic shape can be stretched or squashed to suit your subject, but the positions of features remains constant.

Even when you are exaggerating Mick Jagger's trademark lips, each end of the mouth remains in line with an eye.

Take your time to refine every detail of your subject's face before inking your drawing.

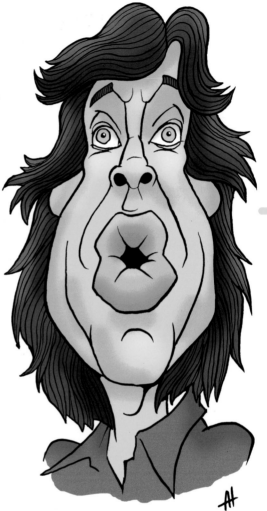

Color is applied to the drawing to emphasize both the lips and the equally distinctive hairdo.

Female faces

While a face like Mick Jagger's (see page 103) has
many interesting lines that lend themselves to
exaggeration, female faces tend to have less of this
kind of detail—you will certainly not be thanked for
adding too many lines if you are caricaturing a live
female subject!

Although you will need to bear this in mind when
inking in the final version of your caricature, there
is no need to let this constrain you when you are
doing your initial facial construction. For the very
reason that there will be less detail to identify the
person in the final drawing, getting the position and
proportion of the features right is even more crucial.
Using pencil guidelines initially to help place them
properly can help a lot.

The personal touch

Getting the details, such as the hairdo and
eyelashes correct can be a big factor in achieving
a good likeness when drawing a female subject.
Although Marilyn Monroe could justifiably claim to
have been the originator of the "glamorous blond"
persona, it is touches, such as the beauty spot and
the correct facial expression, that identify her and
confirm that this picture is of the icon herself
instead of one of her many imitators.

Caricatures, computers, and color

When computer software for producing images was
first developed, it was predicted that hand-drawn
caricature would die out eventually but, in fact,
many cartoonists are now realizing that they can
combine both mediums very effectively.

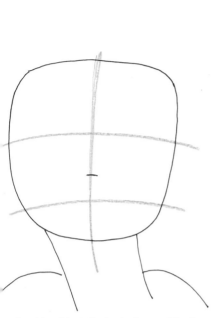

For this subject, the basic shape of the face is made wider but with curved edges.

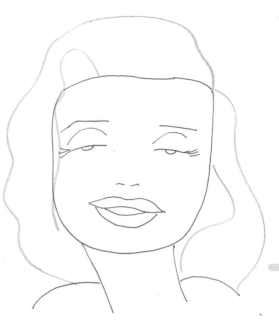

Both the eyes and the hair are deliberately designed to emphasize sexiness.

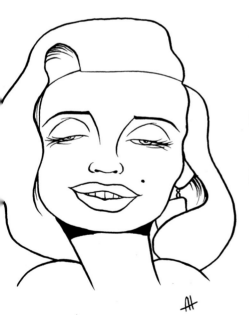

The ink is also applied with a view to emphasizing the facial curves.

Vibrant blond hair and red lips complete the effect, confirming it is Marilyn Monroe.

must know

Since the aim of every caricature is to do what a photo can't, even if you base your computer picture on photos, you may want to add pencil lines and hand-drawn effects to make the end result less clinical.

In the caricature of actor Will Smith shown below, the initial step was to draw the face by hand, using the guidelines already discussed. The picture was scanned into a computer and a paint package was used to apply color and also to distort the image.

Electronic options

The instruction to find as many good reference photos as you can of your caricature subject can be taken one step further when you use a computer. Using photo software, you can experiment with combining a number of different images to achieve an end picture that is distorted but still very recognizable. The other advantage of using software is that it is easier to try several variations on your picture, distorting different features in turn before choosing the one that best suits the end result you are working to achieve.

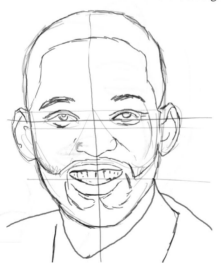

The initial pencil sketch follows the usual proportion rules.

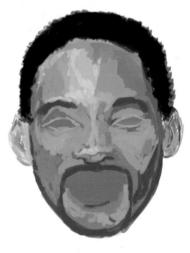

Once the image is imported into the computer, color is applied.

Color conscious

Whether you are coloring your picture by hand or using software, try to identify the signature colors of your subject and, if possible, limit the number of colors you use, so that the focus remains on the face and personality.

Graphic software is used to add details and to stretch the image.

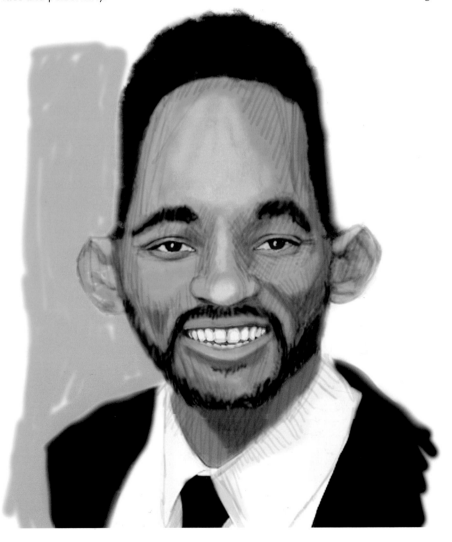

Side profiles can be distorted in several different ways.

Alternatively, the face itself can be made taller and slimmer.

The nose can be made longer as shown in this illustration.

For this (ex) movie tough guy, the chin is key to recognition.

Side profile

Many caricatures are drawn full face, but side-profile caricatures are among the easiest for a beginner to master because, by their nature, they lend themselves to stretching and exaggerating facial features.

Drawings with distinction

The side-profile approach can be particularly useful when caricaturing people whose facial features in general are not very distinctive. The likeness can easily be lost when drawing full face, but in a profile you can, if necessary, create distinctive features artificially by choosing one or two features and deliberately enhancing them, whether or not they are prominent in real life. Side profiles are also useful when caricaturing characters you don't necessarily want to make fun of. There is something about a

side profile that can give a statesmanlike look to a subject, perhaps because it reminds us of the busts of great leaders that are often found in museums.

Choosing the best side

If you are drawing a profile caricature based on an actual live person, remember that most people don't have symmetrical faces, so it is a good idea to look at both the right and the left profile to see which one might make the best cartoon drawing. You will also have heard of actors and other celebrities who aim to always have their best side facing the camera. In fact, this idea stems from earlier times when the portrait or caricature artist was the only camera. When relying on a person's distinctive expression to create a likeness, you will often find this works better from one angle than it does from another.

This picture of Sylvester Stallone emphasizes the hair.

This side profile enhances the jowls of Brando's godfather.

The classic De Niro grimace still works well in side profile.

Learning from other artists

Both your subject and your style should be distinctive. One of the best ways to get used to picking up the distinctive elements that can make a caricature come to life is to look at how a number of different artists approach drawing the same person.

Same subject, different approaches

On these pages, you will see some of the many drawings of Elvis Presley that have been drawn since he first created a stir on the music scene. As with his music, his untimely death and larger-than-life personality will no doubt continue to make him a favorite caricature subject long into the future.

In this caricature of Elvis, the costume is the main identifier.

This manga version of Elvis is still a recognizable Elvis just the same, thanks to the exaggerated hairstyle.

More than one element

With a character like Elvis, cartoonists have several distinctive features available on which to anchor their caricature; some go for the flamboyant stage costumes, some focus on the hairdo and sideburns, while for others it is the distinctive sneer of the mouth that clinches the likeness.

Even when Elvis is drawn in a style with its own strict rules, such as in the manga version shown opposite, it is still possible to recognize who the subject of the caricature is, and having to identify which elements of the subject's look will work best in this style can be a great help to the artist in choosing what to emphasize in the caricature.

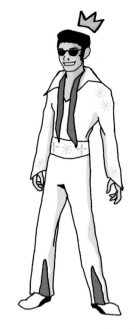

This Elvis is stylized, but the way in which the singer held his hands is subtly picked up on.

This emphasizes Elvis's shades and his nickname of "The King."

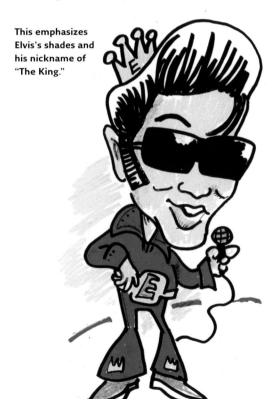

This version is in a more animated cartoon style.

Creative caricatures

You don't always have to draw people as people. The many animated comedies with big stars providing the voices offer budding cartoonists a lot of examples of how animals and objects can be given recognizably human characteristics.

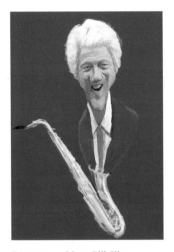

Former president Bill Clinton emerges as a tune from his sax.

David Beckham's face fits neatly onto this soccer ball.

Strong personalities

Often the star of the movie, whether it is a teapot or a fish, will be designed to have some of the facial characteristics of the actor doing the voiceover. In more traditional political caricature, similar transformations often take place. A forceful person might be portrayed as a bear or a bull, whereas someone the artist feels is less trustworthy might find themselves being drawn as a snake.

Drawing people as animals and objects creates two challenges for the caricaturist drawing the identifiable features of the person being caricatured.

Easy recognition

However, there are also some big advantages to caricatures done in this style. When you are drawing someone whose own features are not necessarily distinctive, an animal or object can be deliberately chosen in order to make the finished caricature more dramatic or exciting.

Just as you will need to study someone's face carefully to decide on which features would be best to exaggerate, you may need to experiment with one or two different features of the animal or object you are using to match the correct ones with corresponding features of the person's face.

Here, Gandhi is combined with a map of his country—India.

This Elvis really is "nothing but a hound dog"!

The expertise of Britain's Princess Anne in show jumping is alluded to in this picture.

When all else fails...

Some people are difficult to draw, and you may need the same ingenuity you use when coming up with joke ideas for cartoons to devise new ways of not drawing people. Here are some ideas.

Drawing difficult people

Caricatures often have to be done of people who have suddenly entered the news agenda after living in relative obscurity for the rest of their lives. This can mean that at the point when you need to caricature them it can be hard to find a photograph to draw from. Even more usual is the problem that even if you do have a photo, it is not detailed, clear, or typical enough to get a good likeness from it.

And then there is also the fact that regardless of whether you have a photo or the real person in front of you, some people are just plain hard to draw.

Never say never

If you're serious about being a cartoonist, you will know that your ultimate aim is not to do a picture that looks pretty but to produce one that does the

Presidents and other people who live in famous houses can have their words repeated outside.

job. Even if your own caricature skills are of a high standard, it is useful to know some of the tricks cartoonists often use when faced with difficult caricature situations. Just as you would when coming up with jokes about a person, brainstorm all the images associated with them—distinctive items of clothing, locations they are associated with, people they might hang out with—somewhere among those easier-to-draw subjects will be the key to coming up with a cartoon featuring your impossible subject.

The end result may or may not be a caricature in the strictest sense of the word, but being able to rescue the situation will certainly give you enough breathing space to learn to draw that person properly next time you are asked.

Simply drawing a serious picture but adding a smaller body can create a caricature effect.

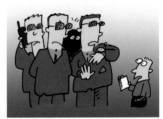

Celebrity bodyguards can be used to make drawing them easier.

Silhouettes of celebrities can often help to mask problem drawing tasks.

Live caricaturing

If your caricatures impress your friends, then try drawing them live. For many cartoonists, having to draw anything in front of an audience, let alone trying to get a likeness of the person you are drawing, can seem very daunting, but, in fact, the live nature of the task makes it easier than you might think.

Putting on a show

While professional caricaturists can draw very well, and you should, of course, be aiming to practice as much as you can to build up your own skills, some of the caricature tricks and shortcuts that have already been mentioned are particularly useful when doing live caricature. You can draw people as animals, objects, or even their favorite superhero. Anything that makes the experience more exciting will help the reception of the end product with your models and audience.

Picking a standard face shape and adapting each likeness to suit helps you to focus.

Turning people into animals and objects always works well.

Talk to your subjects while you are drawing, ask them questions, make (polite) jokes—it makes the experience of being drawn (which most people find uncomfortable) a lot more enjoyable. It also keeps you focused on the person you are drawing and will give you a lot more information and clues to their identity to use in your finished picture

Organize your subjects in a line to avoid being rushed.

Speed is your friend

The fact that you will have to draw your caricature relatively quickly can work for you—it forces you to pick out your subject's most distinctive features and concentrate on those. The more you practice, the looser and more exaggerated your live style will be. Carry a lot of spare paper and pens—you may be surprised at the demand once word gets around.

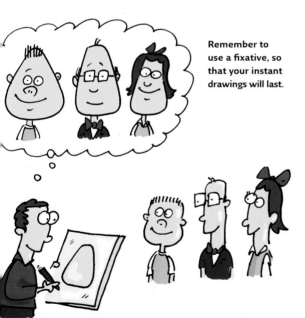

Remember to use a fixative, so that your instant drawings will last.

want to know more?

• Join a portrait class. The end results may be different in caricature, but the basic techniques of drawing faces are much the same.
• Many professional caricaturists have their own Web sites, where you can find a gallery of their work, enabling you to compare techniques with other caricaturists who have drawn the same celebrities.
• Have your own caricature drawn to get an insight into how a caricaturist captures personality.

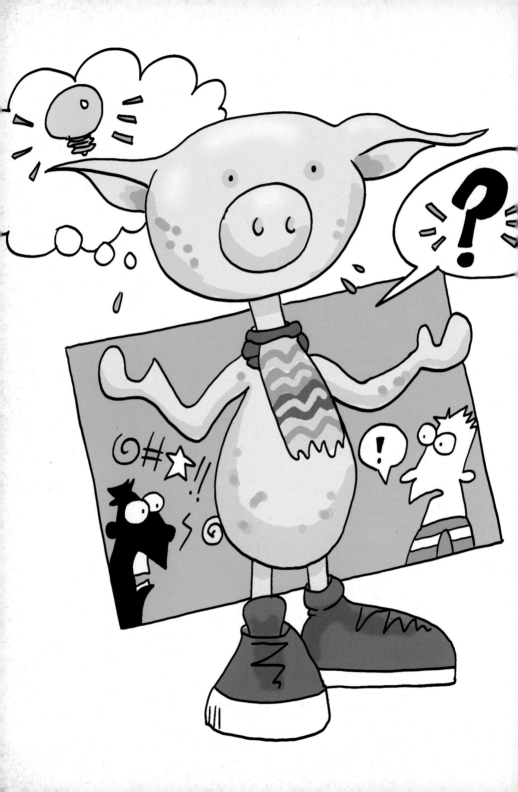

8 Drawing comic strips

The days are long gone when comic strips were seen as just kid's stuff. Stories told through the medium of sequential art can range from dramatic and exciting adventures to accounts of harrowing personal experiences as well as deep and meaningful human relationships. Of course, they can also be as zany, satirical, and fun as comics have always been. Whatever comic-strip style you choose to work in, it will give a workout not just to your drawing skills but to your writing, directing, and acting abilities, too.

Types of comic strips

There are many ways to tell your story. Not only are there many different types of comic-strip stories but there are also several different and distinct formats in which comic stories appear, each of them with their own distinctive traditions and rules.

Opposite: Here is a full page from a longer comic-strip adventure.

This "funny animal" strip is an example of the newspaper style.

Newspaper-style comics

The newspaper style of comic strip usually consists of a short story that is told in two or three panels. If the strip is a comedic one, it will usually contain one joke, although most daily comic strips have the same cast of characters from story to story.

The jokes in a daily strip are often on the same theme for the whole week, and while they are designed to be understandable even to someone reading the strip for the first time, just like a television sitcom, the jokes often have an extra dimension for regular readers who know the personalities of the characters.

The daily strips featured in newspapers can also tell adventure stories although, because of their small size, it can take a number of weeks to tell a story of any length.

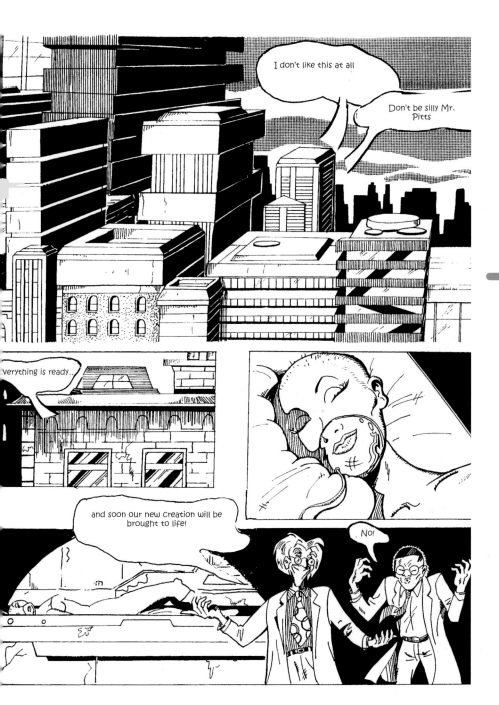

must know

While some artists write, draw, letter, and color their strips by themselves, it is much more common in the commercial world for different specialist artists and writers to work on each separate element of a comic strip.

Comic-book style

Although the original comic books were simply collections of prepublished newspaper strips, the comic-book story has long been a respected medium in its own right. In many countries, the most common format is to tell your story in as many pages as you want (depending on size and budget). In some cases, the story is contained in a single volume, but many comic books contain ongoing stories. In Britain and some European countries, a separate tradition of comics has grown, where the comic book is still a self-contained volume but, instead of having one long story taking up all the pages, it collects together a number of one- and two-page strips, featuring regular (usually humorous) characters.

Big nose and funny animals

Funny stories have always been popular with adults and children. Styles of drawing used in comedy-orientated strips can vary from the deliberately

It is obvious from the drawing style that this superhero story is intended to be humorous.

childlike and exaggerated to pictures which, if not for the humorous nature of the story, could work just as well in dramatic stories. The humor can range from family orientated to very adult and even risqué. A popular technique often used by comic artists who specialize in humor and satire is to tell a story that is comic but use pictures that might suit a far more dramatic style.

Although this strip uses animals, it is rendered in a darker and more dramatic style.

Realistic comics

Given that many comic strips focus on fantasy and superheroics, describing them as realistic may seem a little strange, but the fact is that many comic-book heroes can reflect our innermost hopes and fears just as well as the mythological characters of previous generations did. Many of the recent Hollywood movies based on comic strips have had very dark and adult themes. Even more to the point, the level of realism that a comic-strip artist can bring to depicting a dramatic story is a key factor in getting the reader to accept the fantasy elements of the tale.

This costumed character is drawn in a more realistic style to reflect a more dramatic story.

Just as a comic effect can be achieved by telling a funny story in a dramatic style, strips such as *Maus*, which have depicted serious events, such as the Holocaust, in "funny animal" style have done so to increase the impact of their content.

For a relationship-based strip, a more realistic and stylish approach works best.

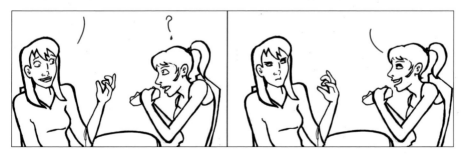

Panel grids and page layout

No matter how wild the comic adventure, the page grid keeps it all in place. It should now be second nature for you to do a rough basic figure before working on your detailed drawings. In the same way, a basic panel grid anchors all of your comic-strip frames and also helps you design eye-catching pages.

must know

Professional artists often work on preprinted page grids designed to suit the requirements of whichever comic book company they are employed by. The grids are printed in blue, so they won't reproduce in the finished comic.

The big picture

Whether your comic strip is one page long or takes up a whole comic book, the overall design has to sufficiently clear for the reader to know in which order to read the individual panels and where to go next. On a more practical level, if your strip is being printed, you may need to leave space for page numbers, and, if your strip runs over several pages, make sure there is enough space left on either side, so the graphics don't run off the edge of the page or get squashed on the side of the page where the book is stapled or bound. Your grid makes sure everything stays in the right place, leaving you free to concentrate on your drawing and storytelling.

Too many similar page layouts can get boring. Variation makes the comic as a whole more interesting to look at.

Frames and freedom

As with a penciled body shape, which you can adapt into any character you like, once you have ruled out a grid to design your pages on, you don't have to be restricted by straight lines or regular shaped panels. Depending on your story, you can draw your panels free hand, make them any shape you want, and, if the story demands it, even drop the occasional panel frame and have your picture freestanding. The underlying grid (which you can erase at the finished artwork stage) is simply the foundation on which you can work as many variations as you want.

A combination of panel shapes will add visual interest.

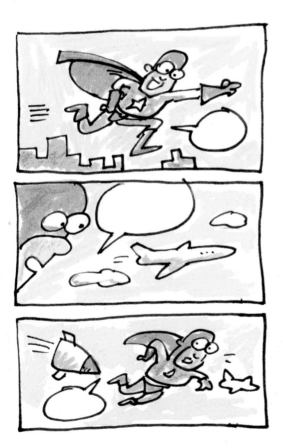

Above: Pages can be broken up into symmetrical panels.

Left: This wide-screen effect allows bigger pictures but less panels per page.

Working with panel design

Always try to make every panel count. Having worked out your overall panel grid, you now have a wide range of effects that can be used from panel to panel to tell your story best.

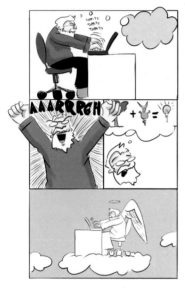

The stretch is emphasized by breaking out of the panel.

Less can be more

With so much going on in the average cartoon story, it can be easy to confuse the reader. With this in mind, cartoonists think very carefully about what they put into each panel. In some cases, the first panel of a story may contain a lot of background detail in order to establish where the action is taking place. However, once the scene has been set, the remaining panels may have little or no background to keep the emphasis on the characters.

At other times, such as in the time-travel panel of the comic strip shown opposite, the background of the panel itself can be used to create a particular effect. There are also times when to emphasize a particularly dramatic moment, the action cannot be contained in its own panel, and it spills out into neighboring panels—although it is important to plan these effects so that the reader can still read enough of the partially obscured panel to work out what is going on.

Letting imagination do the work

One of the most important factors a cartoonist needs to keep in mind when working on a lengthy story is variety, not just in terms of the story being told but for the reader's eyes also. One way of achieving this is to use panels that give a symbolic

or atmospheric interpretation of what is going on rather than a more representative picture. This does not just add visual variety but it also allows the reader's imagination to go to work, sometimes creating a picture that is more humorous, dramatic, or violent than any actual drawing could achieve.

Watch out!

While it is a lot of fun to come up with different and unusual panel designs and effects, be sure you make them "specials" and not the norm. Otherwise, too much repetition can take away their power and make the story too wearying to follow.

Fight panels are often best when they leave the action to the imagination.

In this strip, arrows lead the reader from panel to panel.

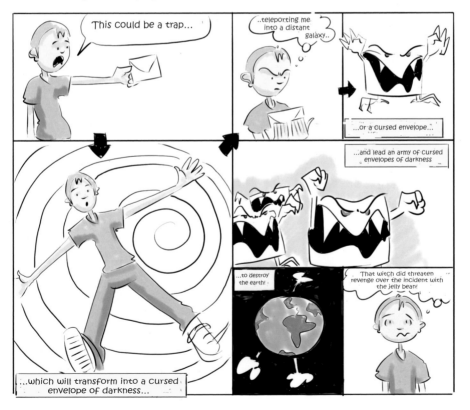

Perspective

You should add depth to your comic-strip world. The more realistic the world your characters live in, the more believable even their most fantastic adventures will be. Developing an understanding of perspective helps to create that realism.

must know

If you need to draw some round shapes in perspective, imagine, or pencil, a box around the circular shape you are trying to draw. If you can get the perspective of the box right, the round shape inside should look right too, and the box can then be erased.

A perspective on perspective

Put very simply, perspective is the concept that objects that are closer to us appear bigger, whereas objects that are farther away look smaller. However, although this does not just apply to whole objects, it does apply to any given point on an object.

With so much going on in a comic-strip story, this can get very confusing, so several different types of perspective are commonly used. The key to drawing perspective is the vanishing point—the point on a picture where everything that is farther away from the viewer gets so small that it disappears. Once you establish where your vanishing point is, you can use guidelines drawn from that point to establish how big or small an object or person (or a point on the object or person) needs to be to be in proper perspective to everything else.

Different perspectives for different stories

The simplest type of perspective is called single-point perspective, where everything in your picture leads toward one vanishing point. This is the most common type used in normal cartoon panels. Two-point perspective is used when you need to show corners or other angles, or when viewing scenes from above or below.

Because comic strips often feature larger-than-life characters and some dramatic angles, three-point perspective is sometimes used to create particularly dazzling drops or towering creatures. In the case of three-point perspective, the third vanishing point is usually outside the panel frame, so it needs to be penciled in while you are drawing and erased later.

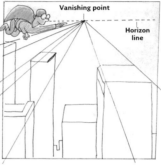

Single-point perspective

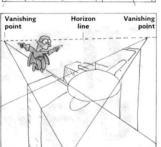

Two-point perspective

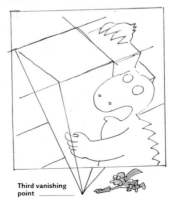

Three-point perspective

Telling the story

A picture is worth a thousand words, and in comics you get to use both. One of the things that sets comic strips apart from single cartoons is the story. Not just a snapshot, a comic-strip story—no matter how short—has a beginning, middle, and end.

From script to strip

There are two kinds of artist working in comic strips. Some people are very visual—they like to tell the story in pictures first and then work out the words later (unless, of course, the strip is one that does not need words). Other equally successful artists are actually writers who draw. They come up with the story in word form first, and only when it is written do they think about how it might be translated into pictures. Many comic strips are produced by teams with a writer and artist working together to produce a finished product. The method you choose is up to you—in fact, you may want to approach a comic strip in several ways to discover which is your most effective style.

Creating your story

Whichever way you want to approach creating your story, just as you do with your drawings, give yourself the freedom to experiment roughly at first before committing yourself to the final product. This is especially important with comic strips, because there is more work involved in the finished pictures and you want to be sure you have a story that works.

Just because every comic story has to have a beginning, middle, and end does not mean that you

have to start at the beginning. You might have an idea for a dramatic or a funny ending and work backward to imagine events that might lead up to that climax. If you do have a beginning in mind and are not sure where the story might lead, the same "what could happen next?" approach that works when producing jokes will help to suggest possible directions.

In this roughed-out version of the strip, there isn't yet a clear ending.

In the finished version of the strip, the artist has decided to show the game board by itself.

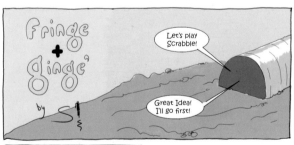 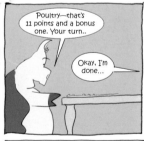

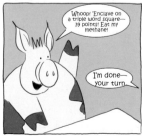 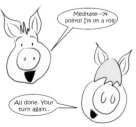 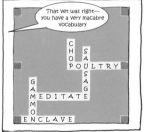

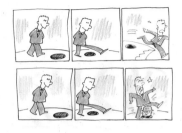

Two different endings for the same comic strip using the "what happened next" technique.

In comics, a significant object can be frozen in midair to emphasize its importance.

Recycling plot lines

It is a standard technique of scriptwriters, whether working in television, film, or on comic books, to take existing plot lines from legends, classic novels, movies, or even from other comic-book tales and retell them. If your characters and visuals are strong and unique enough, the end result should be entirely different from the original; you can even add a humorous or dramatic twist to the ending. Once you have a plot line, it is time to get visual and see how your story can be best told in pictures, in the most interesting way, and with the aim of fitting it into the space you have available for your strip.

Lights, camera, action

It is no surprise that the storyboards used by movie directors to plan the combination of shots they will use for each scene were originally inspired by comic strips. The best comic artists don't just use pictures to tell their stories but select each picture to further the story with maximum impact. Establishing shots show us the location in which the action is taking

This space scene shows what is happening inside and outside the spacecraft at the same time.

In these three panels, our hero arrives just in time. Removing the middle panel still gets him there but with less tension.

place. Mid-shots bring us closer to what is going on, so that we are in the middle of the action instead of just observing it. Close-ups help heighten the emotion and drama and focus the reader on the most important characters in each scene. When planning out your story, you will need to decide not just how many pictures you will use but what kind of picture each one will be to best tell the story.

Slowing and speeding time

Another similarity between comic-book storytelling and movies and television is the ability you have to slow down and speed up time, and to jump from one location to another as the story demands. In fact, comic artists can even take this ability several steps further—they can "freeze" important elements of the story to bring them to the reader's attention, and they can also literally show two different things happening at once.

The longer and more detailed your story, the more of these effects you will need to use in order to keep the narrative fresh and interesting to avoid losing the reader's attention.

This beast is already slow moving.

Breaking the journey into separate panels slows it down further.

Comic-strip lettering

In essence, this is storytelling with sound, but the comic-strip "soundtrack" is a visual element, too. To get the speech and sound of your comic strip right, you must understand the connection between what you see and how you hear in your head.

Getting the order right

The most important factor to bear in mind, at least in Western comic art, is that strips are read from left to right and top to bottom. Therefore, the reader will "hear" any dialogue on the left and higher up first. Of all the mistakes beginners make with speech balloons, it is getting them in the wrong order that is the most common. Just as the visuals of your story need careful planning, where you place your speech balloons is important, too—not least because you have to allow space for them without getting in the way of equally important parts of your drawing.

If you are doing a comic strip that may be printed in several languages, you will usually be asked to leave your speech balloons blank so the dialogue can be added later in the appropriate tongue.

Remember to leave more space than you may need for your own particular language because translated

In these panels, the lettering is used as a design element. Notice that making both numerals and letters this big makes the reader "hear" them as being loud.

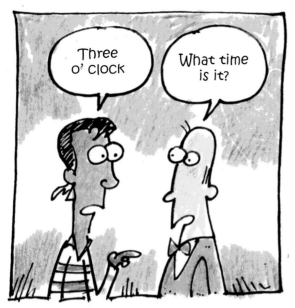

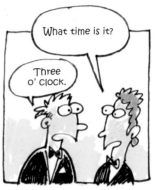

The most common error (left). What you want your reader to hear first should always go on the left of your drawing.

The only exception to the usual left/right rule is shown above— you can put the first dialogue above the other balloons.

phrases can be longer and you need to be sure that the words will fit where they are supposed to.

Sound effects

Depending on how flamboyant you want to be with your sound effects, you can include them in small and subtle lettering or as with some of the most famous comic strips, you can really go to town with big and bold "Pow!," "Wham!," and "Zap!"-type effects, which are striking visual elements of your strip all by themselves. Remember that how you visually design your sound effects lettering can add to the overall effect of your cartoon.

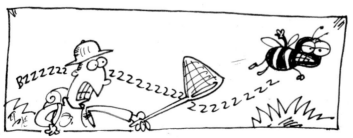

In this panel, the buzzing sound effect not only tells us how the bee sounds but is also a visual way of tracing the flight path.

Producing finished art

Producing finished comic-strip pages is not a speed test—even accomplished full-time professional artists produce a relatively small number of pages per week. Work at a pace that lets you get the small details right at pencil stage, because it is harder to correct errors once you start inking your drawing.

The initial rough strip is designed to get an overall feeling for how you are going to tell your story—it is deliberately loosely drawn.

The finished version retains the simplicity and energy of the original pencil rough.

Pencil roughs

Start off with your basic panel grid and begin to rough out your comic-strip story. You should have already worked out how many panels you will be using and how many pages your story will need, so your aim now should be to design each comic page in as eye-catching and easy-to-follow a way as possible. The idea of your rough pencil version is to capture the energy of your story before you start knuckling down to applying the detail.

Room for inspiration

Although you need to know in advance what action you are going to put into each panel, there is still room for flashes of inspiration at this rough stage. In the strip opposite, about a photographer, the artist realized it would be a nice touch to present the top row of panels as if they were photographs.

Opposite: Once you have an idea of the story you want to tell, you can start to refine the elements, such as polishing your character design.

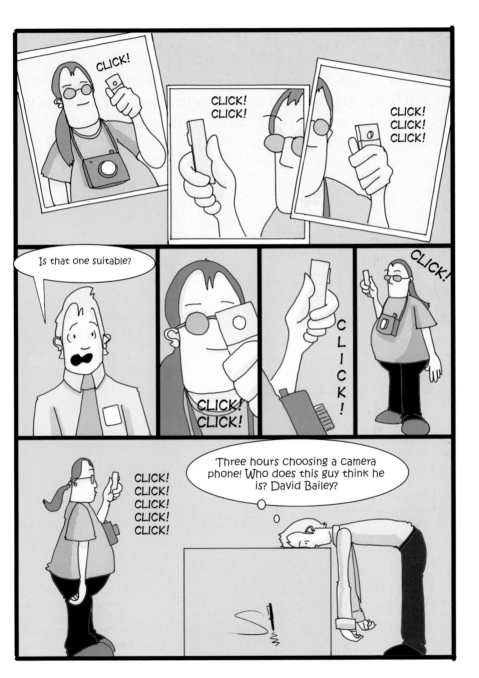

Finished pencils

Your finished pencils should take time to finish. The finished-pencil stage of a comic strip is where the serious work really begins. Roughing out everything in advance and having an overview of the page will allow you to work on each panel in detail to make it the best it can be.

Look closely at these pencils for James Pearson's *Reality Man* strip and you will see that both the light pencil guidelines and the darker pencils have been used to lock in the detail.

Working in stages

There are two approaches that you can choose for producing your finished pencils. Some artists prefer to work through the whole page in sweeps, initially putting in light pencil guidelines for each panel, then returning to each panel in turn to add more and more detail, until the pencils are finally complete. This method helps the artist to keep a sense of the overall story in mind.

Other artists prefer to work on each panel in turn, not moving on to the next one until the one before it is complete. This way of working is particularly popular with artists who like to put a lot of detail into their work, because it gives them an opportunity to focus on making background architecture and weaponry look realistic—even if they are based on fantasy or science fiction.

Lettering space

One thing that most artists agree on, whichever way of working they favor, is that it is usually best to draw in their speech balloons before they start working on the rest of the drawings. It is generally easier to fit elements of your artwork around an important piece of dialogue rather than trying to squash your speech into the available space and still make it legible. The only exception to this rule is when you are planning to paste in your speech balloons over the finished artwork—but even then you need to plan your pictures carefully, so that when the balloon is pasted in, it does not obscure any important parts of your drawing. Reducing your words to the minimum required to communicate clearly usually makes your writing punchier.

In this detail taken from the strip, the artist uses a lighter pencil line on the background figure to create a sense of depth.

must know

The finished pencil stage is the best time to do a final check for any corrections or alterations needed. Once ink is applied, it will be far harder to make any changes.

Inking

The final stage of producing finished comic-book art is one of the most intricate—the inking stage. Whether you're finishing your page in black and white, wash, or full color, the secret of a successful inking job is as much about what you leave out as what you put in.

Opposite: In the final version of *Reality Man*, **the artist has used a very limited tone palette in order to emphasize the dark and futuristic nature of the story.**

Building from the pencils

If your aim for your pencil work is to build a solid foundation over which you can ink your final comic-strip page, try to capture the best finished version of your story possible with your inking, while keeping a feel of looseness and life. For this reason, although comic artists work with precision, they don't always follow each pencil line slavishly; there is still room to add subtle refinements at the inking stage. However, bear in mind that the nature of pen and ink (or brush and ink) is that it is not as flexible or varied in weight of line and hardness and softness as pencil. In most cases, you will need to use several different types of pens or brushes to achieve your finished effect.

Tone awareness

When inking, think about the overall tonal balance of your page. Too many thin lines without any solid areas can make a strip look uninteresting, especially if no color is added, but too many dark areas can weigh the strip down. Try to add your darkest tones last and every so often look at your artwork with half-closed eyes to make sure it has a pleasing balance of light and dark. Because it is hard to undo inking errors, copy your work at the pencil stage, so you have a second chance to get it right later.

want to know more?

• Take a well-known story and rough it out in panel form as a comic strip. Compare it with a picture book or a comic-strip version of the same tale. What works best? What can you improve?
• Find penciled versions of comic-strip pages to compare with the inked or printed final versions. have been made?
• Photocopy and ink another artist's pencil work yourself. What can you do to enhance it while still keeping the feel of the original style?

9 Manga

Although the "manga" style of drawing has become very popular with Western cartoonists and their readers over the past few decades, it has been popular in Japan for centuries. From kids' comics to adult novels, from humorous stories to dramatic adventures, there is a whole world of manga comics and styles. Once you understand the basic differences between manga style (and its animated cousin anime) and the Western style we have been learning, exploring that world for yourself will be a lot easier.

Manga drawing style

Observation is the key to developing your manga style. Although the characters are constructed using the same basic shapes you have been working with in previous chapters, there are some obvious and fundamental differences that will give your manga characters their distinctive look, enabling you to get them right.

must know

Although many people refer to Japanese animated cartoons (and many Western animated series now drawn in a similar style) as "manga," in fact, they are correctly known as "anime" and are an entirely separate and distinct art form.

Large eyes

Probably the single most recognizable difference between manga characters and Western cartoons is the large expressive eyes used in manga, even on older and dramatic characters.

In this comparison of Western- (left) and manga-style (right) versions of the same character, the difference in the size of the eyes and the basic face shape stands out.

Face shape

Whereas most Western cartoon characters' faces seem to be constructed on an oval shape, the basic manga face tends to be triangular with more delicate features, a style that serves to further emphasize the exaggerated eyes.

Like their human counterparts, manga animal characters tend toward more detail and fantasy in their makeup.

Physique

Although manga stories feature their fair share of muscular heroes, not to mention sumo-wrestler types, in general, the characters tend to be drawn in a more slender style. Costumes and hairdos are often more flamboyant and intricate than the simpler outfits favored by Western characters.

While Western characters tend to be rounder in construction, manga ones often feature a more angular, expressive approach.

Creating characters

Because manga can be a very stylized form of comic art, with common character types of a similar look recurring, there are two very important aspects of your characters to consider when you are designing them to stand out—how they look and also what their unique personality is.

Intricate costume design is a feature of the Shoujo style.

Manga boys versus girls

Manga stories tend to fall into two broad categories, which have a strong influence not just on story themes but also on the personality of the characters who act out those story lines. Male-themed manga (which is known as Shounen) often features heroic adventurers, with the emphasis being on struggle, physicality, and, sometimes, a lot of violence.

The girls in these stories can be independent and feisty but are commonly portrayed in a very sexy style, both in terms of dress and character design. In more female-themed manga (Shoujo), the magic and fantasy elements of the style are often more to the fore, with an emphasis on feelings and emotion,

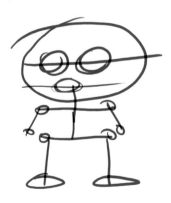

Chibi characters are designed on a deliberately cute big head and small body framework.

must know

Because manga is such a popular and long established medium in its countries of origin, the complete range of manga available can include many subjects, such as cooking or sports. And it can target special-interest groups, such as the elderly, in a specific way that is uncommon in the Western mainstream comics industry.

often symbolically portrayed in the artwork as well as referenced in the dialogue and story line.

The basic manga figure

The greater stylization of manga characters lets you still build them from a basic figure shape, but one that is either more delicate and taller than the Western model, or more rounded and smaller, depending on which manga style you are working in. A common feature of manga is that, in dramatic moments, characters who are normally portrayed in ordinary human proportion can for one or two frames be portrayed in a more extreme deformed style to emphasize powerful feelings.

Bright colors on the finished character reinforce the childlike look of this manga style.

Heroic characters start from a taller, more elegant basis.

Costume and weaponry are suited to the theme of the story.

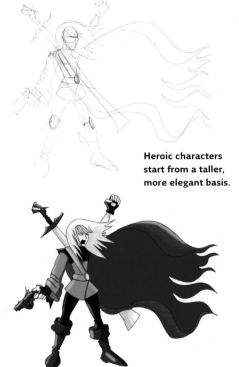

Coloring is also themed to suit the drama of the tale.

Expression and emotions

Because manga faces are simple in design, you may think it difficult to portray a wide range of emotions, but this is not the case. In many respects, manga characters' expressions are more important than for their Western counterparts, where feeling and emotion is more often conveyed via dialogue and captions.

Subtlety and symbolism

While the basic expressions and emotions, such as happiness, sadness, and anger, are portrayed in manga characters using similar techniques to the Western style, the challenge of the manga artist is to go beyond the basics and to use very subtle changes of the facial features to distinguish emotions, which, in less considered hands, might look largely the same.

Graphic devices

While it is surprising how many variations you can achieve with a little experimentation and practice, it is also acceptable to use graphic devices, such as sweat marks or degrees of shading, to accentuate the feelings you are aiming to communicate.

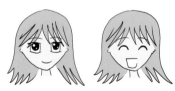

Because the eyes are prominent in manga, simply changing them instantly changes the emotion.

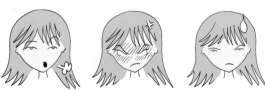

Depression, anger, and frustration are similar emotions, and it takes subtle adjustments to distinguish them.

Extreme emotions

The symbolic nature of much manga storytelling means that while it is generally a good idea to create characters you can draw consistently from panel to panel, as in any comic-strip story, at the dramatic points in the story you can highlight the emotions they may be feeling by drawing a more extreme version of your character's face. You can do this, even in very dramatic and serious story lines, by using exaggerated facial characteristics and expressions, which in a more Western style would be confined to humorous strips only.

For an expression like surprise, an extreme response is often the most appropriate one.

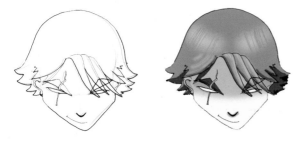

Expression can be a good clue to personality—here both expression and coloring denote a villain.

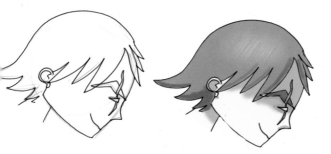

Tilting the character's head down helps to retain the brooding look, even when viewed in side profile.

Poses and costumes

It is interesting to note that in the 1980s, when manga began to really boom as a favorite with young Japanese people, the other medium that also enjoyed a boost was Shogekijo—the Japanese style of little theater. In both mediums, visuals play a huge part in how the characters act out stories and adventures.

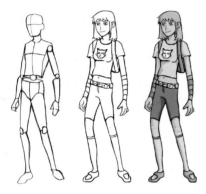

Although this character's clothes are youthful, the relaxed pose suggests more maturity and a steady personality.

This character may be in brighter, simpler attire but the expression and gesture suggest mischief!

Posing with purpose

There are two reasons why how you pose your characters can be particularly important when drawing manga. In the first place, the style in itself is an elegant one, so, like the best supermodels, manga characters don't normally slouch around (unless, of course, they are deliberately doing so). Look at some different characters and see how they carry themselves with style, energy, and purpose.

You can reflect this in your own artwork by doing enough groundwork in your rough pencil sketches. When you are ready to do your final ink drawing, your lines should be definite and confident as well as economical, so that you communicate your picture in as clean and simple a style as possible.

Pose and personality

The second reason for giving some thought to how you pose your manga characters is because their body language can play a big part in establishing a character's personality. Given that the majority of manga characters—unless they are wizards or monsters—tend to look and dress in a youthful manner, it is often their pose rather than their physical appearance that tells us whether the

character is a teenager, young adult, or more mature character. Similarly, the way a character uses their body will communicate whether they are of the innocent type or are more forceful and feisty in nature.

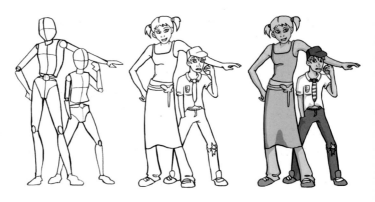

Dressing to express

How you dress your characters can also be a clue to the kind of people they are. In manga, teenagerish clothes are often worn by characters (particularly females) who are well beyond the teenage stage, so it is often subtle costume details that count.

Without any dialogue, the roles of the rebellious brother and the protective older sister are already established just from the poses.

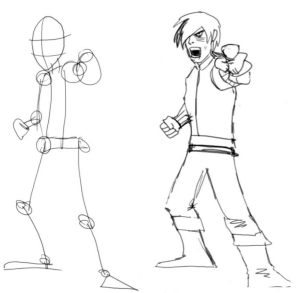

The sense of energy and purpose in this character's pose was established from the initial rough sketch.

watch out

Manga is not just a fashionable comic style; fashion sense plays a big part in manga for males and females. Make sure you are up to date on stylish youthful dressing, or your characters will look very out of place in a manga world.

Creatures

Although cute manga animals are popular in children's stories, it is common for animals and other nonhuman creatures to also play important dramatic roles—again, the key factor is personality. Mascots take us from fantasy to friendship.

Manga animals, such as this cat, are often colored in a way that is the opposite of naturalistic.

Mythical creatures

Because the manga style has strong influences from both history and legend, many Asian characters, such as dragons and other fantastic mythical beasts, are frequently used in manga comics. Sometimes these creatures are portrayed realistically in the sense that they retain their animal characteristics, but usually they have a symbolic value, too. In fact, it is common for the

Notice how this bear has a similar facial construction to human manga characters.

wisest character in a manga fantasy to be a dragon or some other huge and mythical animal who speaks with the voice of aim to make your animal characters as elegant and full of personality as you can, and you can choose to color them in realistic hues or aim for something much brighter to reflect their magical qualities.

Nonhuman heroes

A very popular recurring theme in manga is the "mascot" character. This is usually an animal (a real one or a mythical one) with a special connection to the hero of the story. Not only are they inseparable companions, but often they both display some of the same character traits. In fights or competitions, it is often the mascot character who competes on behalf of the hero. The mascot character does not necessarily have to visually resemble their human owner, although there is no reason why you can't include this touch if you want.

Manga mascots and their human owners share a special connection.

Elegance and a sense of wisdom and benevolence are the keys to designing this manga dragon.

Start with a basic sketch. Aim for a balance between detail and a good, clean definite line.

You can add realistic or fantasy-style coloring. Use shading and tones to give substance.

Drawing mechas

One manga-related theme that has made a huge comeback in hit movies and television shows is "mecha" artwork. Mechas are giant mechanical beings, somewhere between robots and warriors, that lend themselves to incredibly detailed artwork in keeping with their intricate construction.

The nuts and bolts of mecha

You have already learned to construct all of your cartoons from a skeleton and some basic shapes, so it is particularly appropriate to build your mecha characters in a similar way. The mistake made by many beginners is to be put off by the intricacy needed for the finished picture and shy away from mecha artwork. Alternatively, they get so absorbed in the details of the mecha they are working on that the finished article doesn't work as a living character.

The best approach is to invest your mecha with personality at the rough drawing stage and to base it on a humanoid form. You can add details and

Always build up your mecha from a humanistic start point, as shown in this rough sketch.

You can make later versions more metallic and angular than your initial attempt.

Applying some tones to the mecha artwork will help to enhance the metal effect.

gadgets to your heart's content, knowing that the finished product will still work as an overall picture.

Mechanically minded

Another danger when drawing mecha is that because there is less flexibility and variation in the design of individual mechanical components than in nature, it can be easy for mecha artists to fall into the trap of drawing a series of characters that all look basically the same. While this might be a good thing on a robot-building production line, it doesn't create interesting comic-strip stories.

Mechas can be very intricate but repay all the effort involved in drawing and in studying them.

If you study the best mecha artists, you will find that the longer you study their robots the more you will discover small, interesting, and often quirky details that you may have missed before. Even if most readers do miss these details at first, there is something about the fact that they are there that sets good mecha art apart from attempts which are...well, just a little mechanical.

Storytelling and backgrounds

In manga, every part of the picture tells a story. Always remember that because manga is a primarily visual medium, much of the information that might otherwise be conveyed in dialogue has to be delivered by the artwork alone.

Powerful pictures

Just as manga characters themselves are often exaggerated, deformed, or even super-deformed to heighten drama and emotion, many of the other graphic elements of a manga strip are also larger than life. One of the most common devices associated with manga is the presence of bold radiating lines surrounding the characters' heads or emphasizing the impact of kicks and punches. These lines can show great surprise, anger, or a variety of other emotions—or they can simply be used as decoration to increase the vibrancy and

Radiant lines can sometimes be used to depict happiness (above). They can show also anger (right), while the exclamation mark demonstrates surprise.

high drama of manga story lines. Similarly large bold symbols, such as explanation marks (shock or confusion) or question marks (mistrust or curiosity), are often used, not so much as mere punctuation marks but as strong graphic images in themselves.

Background feelings

Another way in which manga artists often go beyond conventional storytelling is in adapting background designs to reflect characters' emotions and feelings. Just as in poetry books, when a hero is feeling warm and fuzzy, the background may also have a warm and fuzzy look, while someone who is under great stress may find that the world around them looks equally jagged and edgy.

This musical background suggests sweetness and grace.

Dark clouds symbolize depression and an impending breakdown.

This jagged background suggests that the character is stressed.

This angry red background in graduated tones reinforces the image of the angry baby in the foreground.

Finished artwork

The challenge of producing impressive finished artwork for your manga is to bring all the different elements of the style together while, at the same time, keeping the boldness, expressiveness, and simplicity of the best manga artwork to the fore.

must know

Legendary Japanese artists, such as Hokusai, whose work influenced manga, often used brush and ink as well as pens. With a tight pencil-sketch foundation, you can experiment with the freedom a brush offers, but make sure you keep a copy of the pencils in case things end up looking a little too free.

Pencil stages

The aim of manga finished art is to be eye-catching, dramatic, and visually elegant. The function of the pencil sketch beforehand is to create the solid foundation that leads to the freedom the inks need to take flight on the paper.

Story progression

Original Japanese manga are read from the back cover to the front page, so unless the reader understands this cultural information, this is likely to lead to a lot of head scratching as to why the characters who were dead at the "end" of the story are alive and well at the "beginning" of it.

Although the popularity of manga around the world has meant that a lot more people now understand the reading backward rule, and American and European translations of original and reprinted manga more often than not print the pages in the Western front-to-back style, there are more subtle ways in which a manga storyteller can lose the audience.

One way is to have too many frames that all look the same, something that can be addressed and resolved by making sure there is a good variation of close ups, mid shots, and long shots.

The other danger is to make each and every frame so intricate that reading them all slows down the pace of the story too much. To avoid this happening, experiment with juxtaposing intricate panels, whether they feature mecha, costume design, or a lot of graphic effects, with some simpler, starker panels to keep your story moving in an interesting way.

Manga tools

For manga, you will need to equip yourself with a good selection of pens. Both thick- and thin-nib pens are ideal for inking. Although the faces and bodies themselves of your characters can be stylized, it is often the weight of the pen used that causes a character to stand out. Even if you do not use them regularly, manga offers you an ideal opportunity to experiment with brush pens just as the traditional Japanese artists used to do.

Start off with a very rough pencil version to get a feel for the action of the story (below). Then firm up the pencil lines (bottom) to reflect the strong confident inks you will be applying to your strip at finishing stage. Avoid airy or flyaway pencil lines—manga is a deliberately stylized medium.

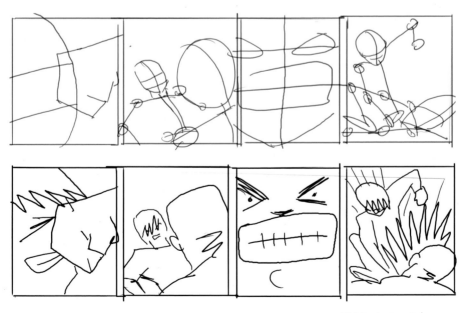

Ink and color

The challenge of the final artwork stage is to bring three elements together—the story, pictures, and decorative elements—in a way that is at the same time balanced but also lively and dramatic.

Inking manga

Because good clean lines are important in manga, it is wise to think of your inking work on a manga strip not in terms of laying ink over pencils that are already in place (although that's what you are doing), but to try to invest your ink line with the same energy you would use if you were drawing the pictures for the first time. Having the pencil lines as a guide gives you the freedom to finish your picture in controlled confident strokes of your pen or brush. If the line varies slightly from the original pencil, that is probably an improvement instead of a mistake—note the final panel of the strip opposite. Although the hero's face is exaggerated and not physically correct, the one staring eye and dramatic spiky hairline reinforce the sense of unleashing his powers with wild abandon. Notice also that in the first panel it is the radiating background lines rather than the drawing itself that gives the punch its sense of motion and impact.

Coloring manga

Although the strip shown opposite is in color, it is very common for manga to be drawn using only blacks, whites, and gray tones. Whatever palette you use, color choices are particularly important, and not just from a decoration point of view—they aim less for photographic reality and more to establish a

mood for the story. In this fight scene, the reds and oranges suggest anger, violence, and frenetic activity. Contrast these with the blues in the second panel, where time stands still as our hero faces the choice of giving in or taking on his aggressor.

The tones on the bodies create a sense of solidity and roundness that complements the stylized and linear quality of the drawings themselves.

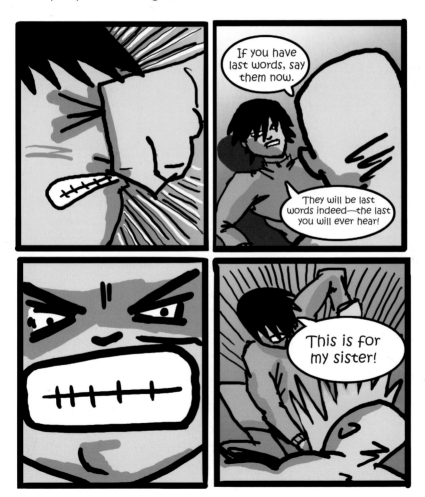

Manga into anime

Many classic manga stories and characters have made their way into anime versions, and anime productions have been retold as manga. With the development of cheaper animation software, more enthusiasts are able to try their own anime along with their manga work, even from basic computers.

A still frame from anime that freezes a moment of anger.

Zooming in for a close-up serves to increase the intensity.

Streamlining your work

While animation in general is discussed in more detail in the next chapter of this book, the key to successfully translating your manga into anime (or producing anime from scratch) is to understand the differences between the two media.

Even with computer software doing the donkey work, anime requires you to create recognizable characters that can be posed and reposed as your story unfolds, and for this reason simplicity and boldness of design are even more crucial than in manga. Ask yourself if you really need any extra intricate design details and, if you do, be prepared to render them over and over.

A particular aspect of manga that you will need to think about is how you reproduce the symbolism in your anime productions. In a comic strip, the reader can take time to look at a picture and work out the deeper meaning. Moving pictures do not offer that facility (unless you want to keep pressing the pause button constantly).

If your computer software allows you to zoom in on or pan across still pictures, that can sometimes be even more effective than having everything moving all the time.

This manga-style storyboard for an anime movie will need to be simplified and stylized for the final production.

Soundtrack

The element of anime that does some of the same work of interpretation and reinforcement that graphic techniques provide in manga is sound. Music can be particularly important because it can set and alter moods just as color does visually. As long as you can record dialogue clearly for your anime, don't worry too much about lip synching. As so many original anime are seen in dubbed versions, a little delayed speech can reinforce instead of take away from the anime feel.

want to know more?

• A great place to start exploring in depth is a Web site that links to many other Web sites on manga and anime topics www.Anipike.com
• The Manga University site provides step-by-step lessons in drawing manga at every level, from beginner to expert. www.howtodrawmanga .com
• If you want to learn enough Japanese to read original manga, begin by learning it from a manga-style book: *Japanese in Mangaland* by Marc Bernabe (Japan Publications Trading) ISBN-13: 978-4889961157

10 Putting cartoons to work

Whether or not you have plans to become a professional cartoonist, drawing your cartoons is only half the fun—like any other work of art, your cartoons only go to work when someone else gets the chance to look and laugh at them, or to lose themselves in your exciting adventure stories. In this chapter, you will discover a wide range of different ways to get your work in front of your audience, whether it consists of thousands of readers or viewers, or you make your work into a special and unique gift for an audience of one.

Cartoons unlimited

The only thing that truly limits the uses to which you can put your cartooning skills is the parameters of your own imagination. Anything you can make a mark on, you can cartoon on.

No place like home

Although you will have the chance to explore a wide range of commercial applications for your cartoon skills in this chapter, including making your living from cartoons, there are many uses to which you can put them in your own home and simply to have fun with your family and friends. Personalized cartoons make unique, memorable gifts, whether presented as simple hand-drawn greetings cards or more elaborate projects, such as T-shirt designs.

You can use some fabric paint to decorate clothes (although not while they are being worn).

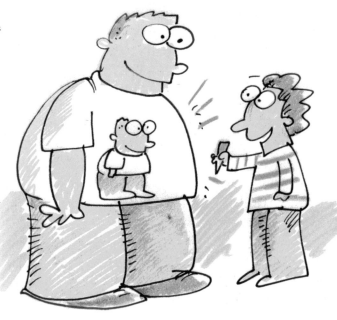

Merry Christmas

Happy birthday

You can personalize T-shirts and other items of clothing by drawing cartoons with fabric paint, or if you have a number of gifts to give, create a design that can then be printed by silk screen on as many garments or other items as you need. Most local print stores and, in many cases, even your own computer's printer can produce the necessary transfers relatively inexpensively.

There are not many commercial cards for unique family occasions, such as those people who have birthdays on Christmas, but you can create one.

Practical uses for cartoons

Cartoons can also have practical and educational value. Notices and reminders in the home or the office are far more likely to be noticed when they are accompanied by a specially drawn cartoon. You can also use an overhead projector to enlarge your normal-size cartoons, so that they can be traced onto larger areas, such as entire walls, to create eye-catching mural designs.

Reminders to recycle work better in cartoon form.

Using your computer

Computers can do the work, but the ideas and skills still come from you. For professional cartoonists, the computer has become a very important tool; even the simplest home computer can be used for a range of projects. It is not necessary to be a technical wizard, but there are some important guidelines to bear in mind.

must know

When you are buying new graphic-design software, always check that the package you are purchasing is compatible with your particular computer system, otherwise it may not work.

A scanner is the most common way of transferring artwork to your computer.

Digitizing your work

There are currently two main ways to transfer your cartoon work from the page into the computer system. The first is to use a scanning device, which is simply a machine that enables you to photograph your physical drawing and then translate it into a computer image with which your computer's graphic software can work and manipulate.

Some artists draw a basic black-and-white image and then, once it is scanned into the computer, they add a whole range of graphic effects, whereas others prefer to complete the drawing in the "real world" and simply use the computer as a means to send their finished work via e-mail.

The second method for computerizing your work does not involve any paper at all—you simply draw your picture directly on a touch screen belonging to one of the many kinds of graphics tablets that are currently on the market. In the same way that an electronic keyboard can be adjusted to make the key sound like any instrument, from a piano to a saxophone, the stylus on a graphics tablet can be made to produce line and colors in many different media, which range from pencil to watercolor and even oil paint.

A computerized cartoon factory

After storing your picture electronically, there are many software packages you can purchase that will help you insert your picture into prepared designs for a wide range of gifts, such as calanders, diaries, and place mats, all of which can be printed out directly from your home printer.

A more recent innovation is the development of commercial Web sites that allow you or your customers to order a variety of different gift items, including T-shirts, clocks, and mugs, using your own cartoon designs. The great advantage of this to the beginner cartoonist is that the drawing is simply stored on the Web site and, therefore, no products are manufactured or shipped until the customer has already made a payment.

Graphics tablets are portable and they can be used anywhere.

Although the pencil and color effects look hand drawn, they are produced entirely by computer.

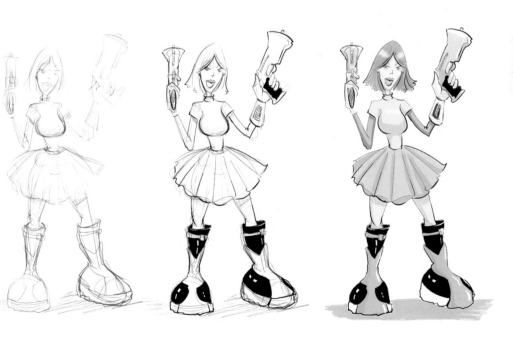

Cartoons on the Web

The World Wide Web offers a plethora of new opportunities for using your cartoons. Because the best cartoon in the world is of little use unless there is an audience to appreciate it, one of the best ways you can reach the widest audience possible with your work is by using the Internet to your advantage.

watch out!

If you are regularly sending pictures over the Internet and, especially, if you are downloading pictures from the net to your own computer, make sure you have up-to-date security software in place to avoid virus-laden or infected files.

Social networks

Popular social networks, such as Myspace, Facebook, and Bebo, let you upload cartoons in the same way as photographs and graphics. Having a cartoon version of yourself instead of the normal portrait photo is a great way not only to make your page stand out but also to protect your privacy in such a public forum. Each network has its own uploading system, so it is important to check that you have saved your computer graphic in a format and size that is compatible with that particular system.

Online galleries

Another way to use the Web is to upload your best cartoons into one of the many online galleries around. In some cases, the sites are merely a place

A page that is heavy with information can be livened up with a cartoon drawing.
http://www.parentalk.co.uk

to display your work and to look at other people's work. In other sites, however, as well as displaying your work, you can sell your pictures if someone wants to buy the original (the site owner will usually take a commission for this). However, you should be aware that once your work is displayed on the net, there is not very much that you can do to prevent other people from copying it and using it without your permission.

Working on the Web

Web designers are constantly looking for exciting new means of communicating information to their audiences in eye-catching and interactive ways, and cartoons can often be the ideal method of doing this—from just a simple cartoon picture to enliven an otherwise information-heavy Web page to interactive cartoons that provide different pieces of information when they are clicked on.

Cartoons can replace photos on networking sites.

On this site, just clicking on the different elements of the cartoon map leads the visitor to specific local information.
http://www.bbc.co.uk/kent/thamesgateway

Animation

Traditional or computerized, it's still the cartoon skills that count. While some of the skills required for animation—patience, precision, and a degree of familiarity with technology—are not always found in every cartoonist, cartoons and animation have certainly been equally popular cousins for a very long time.

must know

It takes a surprisingly small number of drawings to create a cycle of movement. Once you have broken the motion up in three or four moves, you can simply repeat the same drawings over again.

A changing medium

While it would take a whole book to explain the wide range of techniques and styles of animation, and many years of practice to become proficient in each style, the basic principle of animation, like those of drawing cartoons, remains an exceedingly simple one. It is the principle of persistence of vision, which means that when the human brain is shown a series of similar drawings passing rapidly in front of the eyes, it has difficulty in separating one drawing from another and thus the illusion of movement can be created.

For many years, the only way to produce this illusion with cartoons was to employ many artists (sometimes working in different countries) to draw hundreds and hundreds of almost identical pictures

In traditional and computer animation, drawings are layered.

This is the background layer of the drawing.

Here, both the front and back layers are superimposed.

and then to photograph each one individually. With new developments in computer technology, it is now possible to draw a much smaller number of pictures—often just the extreme points of a particular action—and then have the computer fill in all the in-between drawings that would usually be drawn by hand.

Homemade animation

However, despite technological advances, the first step in being able to produce animation is still for the artist to understand how basic movement works, and then to have the ability to capture that movement on paper. For this reason, it is still a good idea to practice your animation workouts, as beginners have always done, with simple flip books, where a number of sequential drawings are made, laid one on top of another (or drawn on the pages of a notebook), and then flipped to see how smooth the impression of motion can be made to look.

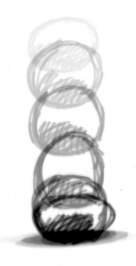

The two bouncing ball drawings above look simple, but to capture this sense of motion takes a lot of practice.

Although this is a nature-based scene, all the elements have clearly defined edges to set them apart from each other.

In this frame, not only is the running character animated but his shadow is also moving.

must know

Many widely used animation packages, such as Adobe Flash and Toonboom, let you download limited use trial versions from their Web sites. It is worth doing so to evaluate whether or not the package is right for you.

Computer animation

While it is perfectly possible to create animation from scratch, using one of the many popular animation software packages that are available, many professional animators still prefer to draw their initial images by hand and then scan them into the computer to work on. Software packages range from the very basic to the extremely sophisticated, and from free versions that can be downloaded from the Internet to the same costly software that is currently used to produce Hollywood movies. However, it is always worth remembering that the more sophisticated the software, the more dedication and time you will need to commit to mastering it.

The best of both worlds

Most top animators advise that the best approach you can adopt when you are experimenting with computer animation is to take things slowly and just set yourself small goals to begin with—for

The frame above combines a hand-drawn character with a computer generated blurred background to enhance the feeling of depth.

Computer animation does not have to look complicated to be effective, which is demonstrated by this stylized image.

Although software was used to produce these three-dimensional images, the lighting effects creating depth came from drawing practice.

instance, make sure that you can animate a ball bouncing realistically before you attempt to recreate the finale of *Fantasia* or *The Lion King*. You will know that you are getting somewhere when you can use the computer to achieve the animation effects you desire, as opposed to filling up your projects with particular animation effects just because your computer can do them.

Marketing your cartoons

It's not what you sell but who you sell to. For many beginner cartoonists, the moment that confirms that they have made the breakthrough from learner to working artist is when someone else puts their cartoon to use. They may even offer to pay for using it, but for many of us that's just a bonus.

must know

Try entering the terms "trade publication" into an Internet search engine and adding a word describing your favorite hobby or other topic of personal interest. You should be able to find several related publications and Web sites to pitch your cartoons to.

Crowded markets

The best way to maximize the chances of someone using your work is to let as many people as possible know that you are available to do cartoons for them. Unfortunately, however, many beginners go about this process in the wrong way—one that, no matter how talented they are and how hard they try, will probably lead to disappointment.

Stop and try to think of all the major publications, Web sites, or television shows you know that use cartoons regularly. Have you thought of some? The chances are that every other beginner as well as many established cartoonists have thought of them too. With so many cartoonists aiming for the same

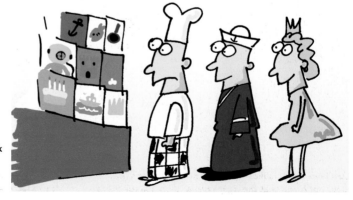

Most mainstream magazine stores and libraries usually stock a limited number of magazines on a wide variety of topics.

limited spots, it is no surprise that so many cartoon dreams end up in frustration and disappointment. However, there is another approach you can try. Hidden from the mainstream are thousands of other cartoon markets, and one of them may be exactly the right one for your work.

The marketing mindset

Think about your hobbies, your interests, your day job, your life experiences—there are probably some publications and Web sites specially devoted to these topics. Once you identify them, they may be interested in using your cartoons—after all, there will be far fewer cartoonists competing for these markets. The practice you gain from being a bigger fish in these smaller ponds can be the ideal beginning to more mainstream success later.

Specialist publications have better opportunities for cartoonists who know their particular market.

It's easier to draw cartoons about something you know well.

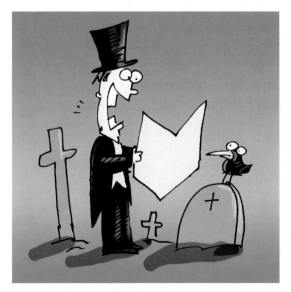

Just because a publication does not run cartoons now, it does not mean that the right ones won't persuade them.

Read each magazine carefully and try to picture the typical reader.

Submissions and syndication

Presentation is the key to success—it's not enough just to be a good cartoonist. When you are submitting your work to editors and other potential customers, how you present your cartoons is equally important. It's the simplest things that count.

must know

If you are sending work that may not be looked at or printed straight away, remember not to include material that is too current (and will soon be out of date) or, if the magazine or site is not a local one, that will not translate across international boundaries.

Put yourself in the editor's chair

Whether you are sending your work by e- mail or by mail, doing your market research will help to set it apart from the many submissions that most editors receive daily, which are often either unsuitable or unusable. This is why, once you have targeted a particular market, it is so important to really study the particular publication or Web site to which you are submitting your work.

You will get a much better idea of the kind of topics and the point of view that most interests the readers by taking time to read the articles and letters in the magazine you are targeting, or on its Web-site forum. Thus, there is no point sending in some cartoons that make fun of authority to a magazine or Web site that is written for, or by, law enforcement officials. However, submitting a cartoon or strip that identifies the lighter side of the stresses and strains they have to put up with in their work could prove very popular.

Equally, take a look at the size and format of the cartoons or illustrations that are already featured in that publication. If all the cartoons are in black and white, then yours should be, too. If they are all square, then there is little point in submitting a long comic-strip design.

A short, professionally written and concise letter or e-mail, such as the example on page 181, will let the publication know you really mean business—and that you understand their business. Along with your letter, send a small selection of your best cartoons, enough to show you have more than one idea but not so many that you end up creating more work for someone who's already busy.

If at first you don't succeed...

Once you have sent your work to one editor, you should concentrate on trying some more outlets instead of bombarding the potential client for an answer if you don't hear back immediately. If they like your work, they will get back to you.

Alternatively, you may get a rejection—in which case, congratulations! Every cartoonist acquires a collection of these before their first break—and occasional rejections pop up even during the most successful career. The most important thing is to persevere with your submissions.

If you have just sent one batch of cartoons to one person, it is very disappointing if it comes back (or sometimes you'll simply hear nothing at all, which is why you should never send original art through the mail). However, if you always make sure that you have several pitches out there, you will still have something to look forward to and will have created far more opportunities to land that first job.

If you get a rejection, but with some comments added, take them onboard; you don't always have to agree with them, but it may be that adjusting your work accordingly will lead to a sale next time you submit to that particular editor.

A small selection of your best work always beats a mountain of random shots.

Editors are very busy people, so submitting your work politely will work better than stunts.

Syndication

Another way to sell your cartoons is via syndication. In this system, a cartoon or comic strip does not just appear in one publication but the syndicate distributes copies of the same cartoon to editors all over the world. Many of the most famous cartoon features and comic strips, ranging from *The Far Side* to *Peanuts*, are syndicated cartoons. From the point of view of editors, they are getting first-class cartoon material for a fraction of what they would pay if it was specially commissioned. For the cartoonist, it can mean worldwide fame and universal recognition.

Wormwood

Wormwood is a demon who has a very bad temper, a mind full of sneaky schemes...and a habit of accidentally doing good things for people.

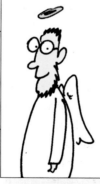

Charlie Angel

Charlie is Wormwood's enemy or would be, except that angels don't like to make enemies. He is constantly trying to befriend Wormwood...which just annoys him even more.

Harpo

Harpo is Charlie Angel's dog. For a heavenly hound, he misbehaves a lot!

Of course, for this reason, the syndication market is a hotly contested one, making it all the more important that when you send in your ideas, you send enough to demonstrate that you can keep good material coming for as long as the syndicate requires. If you are submitting a comic strip, as well as your sample cartoons, it is a good idea to send some character outlines, as shown opposite.

As already mentioned in the comic-strip chapter, it is regular characters that bring the reader back to the comic strip each day, and the syndicate needs to be convinced that they are universal enough to generate ongoing stories. Character merchandising is also a big part of a cartoon strip's earning power, so demonstrating that you have really marketable and interesting characters will make your strip all the more attractive.

must know

Remember that even when your cartoon gets printed you may not get paid unless you submit an invoice. Discuss this with the person who commissions your work to find out what their payment system is.

Money, money, money

"How much do I charge is?" is a common question asked by beginners, but there is no one answer. Different publications and cartoonists have different prices—often for exactly the same type of cartoon, depending on the budget the client has available.

In the early stages of your career in cartoons, it is not uncommon to work for nothing in order to build up a body of printed work. However, even if you do this, it is worth calling the art departments of the type of magazine or Web site you are working for to check their rates for illustrations. Use this information as your rule of thumb when you are pricing your own cartoons. Even if you are not getting paid for your work, you and your client should treat it as the valuable commodity it is.

Respect your work—make sure you mail it in a stiff envelope.

Preparing for print

One you have sold a cartoon idea, your job is not finished until it is ready for print. You, the page designer, and the printer are a team, even if you never actually get to meet each other.

Hard and electronic copies

If you are asked to provide a "hard copy" of your work, it simply means you need to send as clean a copy of your original artwork to the publisher as you can, either by mail or by courier. When sending an electronic copy by e-mail (which is increasingly the most common way in which you will be asked to make submissions), check which format your publisher specifies artwork—jpegs and PDF files are among the most common ones. If your work is saved as the wrong type of file, it can often be bounced back by the recipient's security software.

You also need to find out at what resolution the files are needed. For most high-quality print jobs, the work will need to be sent at a higher resolution than you would normally use for your hobbies and home-based projects.

Helping the printer to help you

If your work is being used as part of an overall design (such as the drawings used in this book), there are a number of things that you can do to help the designer and printer present your work in the best way. The simplest of these is to be aware in advance of the space your drawing needs to fill; there is no point sending a rectangular shaped drawing if the available space is a square or vice

versa. Because drawings are often produced at a much bigger size than they are printed, it is always worth checking that when the picture is reduced to fit the available space that any small details will still be visible, or, if this is not the case, that they are not essential to understanding the cartoon.

Another good idea is to always check your spelling; many cartoonists tend to be less good with words! This is particularly important if you hand letter your cartoons, because any mistakes will be much harder for someone else to correct.

Finally, if you are sending a number of cartoons at once, make sure that you label each one so that the designer knows on which page, or with which piece of text it goes—don't assume that this will be obvious from the text or cartoon themselves.

The artist, the designer, and the printer all play a part in getting the cartoon to the reader. Modern technology means they are sometimes the same person.

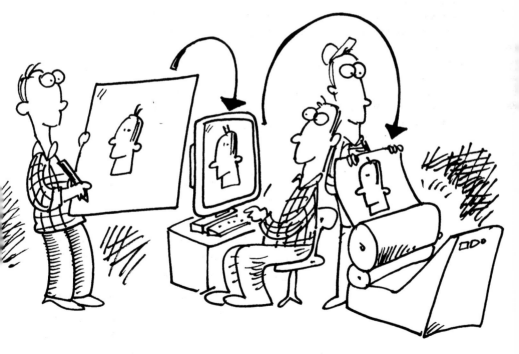

Your cartoon career

Making your cartoons pay can be a serious business. If you have enjoyed learning to cartoon from this book and have even sold some work using the ideas in this chapter, then you might be tempted to consider it as a part-time or even a full-time career. It is certainly possible to make a good living as a cartoonist.

Make sure you keep up to date on the latest cartoon trends.

Step by step

Just as you can only improve your drawing skills one step at a time, building a successful cartooning business takes time and planning. The first thing is to let people know you are available for work—use business cards or mail leaflets for your potential customers and make sure that everything you produce looks as professional as possible.

Your Web site

It makes sense to have a Web site of your own. There are many free packages available, both online and to buy, which let you create a very impressive-looking site, even if you have very little technical knowledge. Choose a site design that is compatible with your own style of work: dramatic if your work is dramatic, or comic if your work is more humor based. However, don't make it too complicated; remember that the more pictures there are on a Web site, the longer it can take to load and that not every computer connection is superfast.

Make sure you check and answer any e-mails to your site regularly. You don't want to discover that you have been offered a job with a tight deadline but find out about it too late to accept.

Keep records of all your cartoon income for the taxman.

Get your finances in order

Make sure you are organized about finances—both the money coming in and going out. Although you will have to pay tax on any money you earn from selling your work, you can deduct the costs of the materials you have to buy and can save even more money by buying the materials you need in bulk.

An ongoing journey

The mark of the most successful professionals in any industry is that they never stop learning. Visit comic stores and fairs—it is helpful to meet and learn from other cartoonists and keep up with the latest trends. It is also a good way to discover new markets for your work. Wherever you end up using your cartoons, whether in print, online, or simply on your bedroom wall, keep practicing, keep improving, and, most of all, remember to keep having fun!

Cartoonist
Your name
Your address and telephone
your e-mail and Web site

Make sure that all your contact details are on your work.

Even those cartoonists with different skills can often work together very successfully as a team.

want to know more?

• www.successful cartooning.com is the companion site to this book and contains links to many other useful career resources and websites.
• www.cafepress.com and www.lulu.com enable you to upload and sell cartoons on a variety of merchandise.
• www.vistaprint.com offers business cards, letterhead, and other stationery that can be designed online using your own images.

Glossary

Acetate Transparent sheet placed over artwork, allowing cartoonist to write instructions and\or indicate a second color.

Animation Moving pictures that often use cartoon drawings or computer-generated cartoon-style characters.

Anime Japanese animation style (not to be confused with manga, which refers to comics).

Anthropomorphism Giving animal cartoon characters human characteristics.

Airbrush Pen-shaped tool that sprays a fine mist of ink or paint to retouch photos and create continuous-tone illustrations.

Artwork All original drawings (may include type and photos) intended for printing.

Bitumen "Beautiful Boy" characters commonly found in manga.

Bleed A part of a drawing that extends beyond the edge of a printed sheet after trimming.

Camera-ready copy. A cartoon or comic strip that can be sent to the printer without needing any further work before it is printed.

Caption The words that go with a cartoon, usually printed below the picture if the publication does not use speech balloons.

Cel Transparent or semitransparent acetate or paper sheet on which original animation drawings were originally done.

CGI Computer Generated Illustration (or imagery) used to produce animation and comic strips.

Comix Term used to describe "underground comics," which were originally more adult in theme than those published by mainstream comic companies, and often self published. More recently, the term refers more to a style than a particular type of comic book.

Copyright Although a cartoonist may sell or give away a cartoon drawing, the right to make copies of or republish it remains with the artist unless that is also part of the deal.

Creator An artist or writer who invents a comic character or story. Successful comic characters can be big business in movies and games as well as their original medium, so comic creator's rights can be a major source of contention if negotiating with publishers.

Crop marks Lines near the edges of an image indicating where the page will be cut in the final printed version. Anything drawn outside these marks will be lost.

Dialogue What people say in a cartoon or comic, usually communicated to the audience via speech balloons.

File format The type of computer file a client needs your cartoons sent in, if submitting electronically, to be compatible with their own computer and printing equipment. Jpeg and PDF files are the most common.

Flash Most common software used by Web designers to animate cartoons or photographs.

Gag cartoon A single cartoon picture, containing one joke.

Golden Age Comic fans divide the history of the medium into ages. The Golden Age refers to the years when classic characters, such as Superman and Batman, were created. Silver Age refers to the 1960,s when newer more socially aware characters appeared, such as Spiderman and the Silver Surfer.

Graphic novels Comic-strip stories published in their entirety and in book form, often with serious or adult themes.

Gutter Inside margins of a book or comic book page on either side of the binding. If you draw a panel across two pages, make sure there will be no important details pinched in the gutter, or obscured by a staple.

Inker Specialist artist who completes pencil drawings of other artists in ink.

Libel A law referring to the publishing of something false which damages a person's reputation. Cartoonists need to be careful not to make fun of people in a libelous way.

Line drawing A single-color (usually black) drawing with no added tones.

Mangaka Artist who works in manga style.

Marvel style A method of comic creation (developed by Stan Lee at Marvel Comics) wherein instead of the artist working from a prepared script, the writer and artist brainstorm a story together. The artist breaks it down into visual form and the writer adds dialogue and captions.

Newsprint Cheap paper used in printing newspapers and, for many years, comic books. Ink tends to spread on newsprint, so finely detailed drawings suffer.

Origin Comic-strip story of how a superhero got his or her powers. In long-running series, the origin story is frequently retold for the benefit of new readers.

Panel One of the single pictures put together in sequence to tell a comic-strip story.

Parody Humorous retelling of a serious story; a popular story-generating technique.

Penciler Artist who does the pencil drawings for comic strips (they may be completed by other artists).

Pitch Send cartoons to a publication (usually unasked) in hope that they will be interested in using your work. Also known as sending work "on spec" or "unsolicited."

Plot Basic story line of a comic adventure.

Portrait Page or picture design in which the height is greater than the width (opposite of landscape). Most comic book pages are portrait although panels within the page grid can be landscape.

Rejection slip A note (usually preprinted) returned to the cartoonist with work sent to a publisher, letting him or her know that it has not been found suitable.

Resolution Sharpness of an image on film, paper, computer screen, disc, tape, or other medium. Cartoons for final printing usually need to be submitted in high resolution.

Retro Comics or animation deliberately drawn in a style from a previous era.

Scale To identify the percent by which photographs or art should be enlarged or reduced to achieve the correct size for printing. Most cartoons are drawn at least twice the size they will be printed at.

Specifications Detailed description of how cartoons should be produced to suit a client or publication. Should include finished size of printed cartoon, whether black-and-white or color artwork is supplied, and in what file format and resolution the work should be submitted if being e-mailed.

Splash Opening panel of a newspaper comic strip or the opening page of a comic-book, story which is often bigger than the normal panels and designed to set the scene and grab the reader's attention.

Superhero A comic book character who possesses special powers.

Thumbnails Initial rough ideas jotted on virtually anything in regard to initial concept of a future project.

Web comic A comic that is only published online (an increasingly popular format).

Need to know more?

Organizations

Association of North American Editorial Cartoonists

3899 North Front Street
Harrisburg, PA 17110
tel: (717) 703-3086
www.editorialcartoonists.com

The Cartoonists Club of Great Britain

29 Ulverley Crescent
Solihul, West Midlands B92 8BJ, England
www.ccgb.org

Professional Cartoonists Organization (Feco UK)

www.procartoonists.org

Galleries, museums, and libraries

Cartoon Research Library

Ohio State University
27 West 17th Avenue Mall
Columbus, Ohio 43201-1393
www.osu.edu

Cartoon Art Museum

814 Mission Street
San Francisco, CA 94103
www.cartoonart,org

Canadian Museum of Caricature

395 Wellington Street
Ottawa, K1A ON3, Canada
tel: (866) 578-7777

Cartoon Gallery

39 Great Russell Street
London WC1B 3PH, England
tel: (171) 636-1011

Cartoon Museum

35 Little Russell Street
London WC1A 2HH, England
www.cartoonmuseum.org

Galerie Lambiek

Kerkstraat 132
Amsterdam, 1017 GP, NL
tel: 31 20 626 7543
www.lambiek.nl/home.htm

Publishers and syndicates

2000AD

www.2000adonline.com

Cartoonists and Writers Syndicate

www.cartoonweb.com

DC Comics

www.dccomics.com

King Features Syndicate
www.kingfeatures.com

Marvel Comics
www.marvel.com

United Features
29 Ulverley Crescent
Solihul, West Midlands, B92 8BJ, England
www.unitedfeatures.com

Universal Press Syndicate
4520 Main Street
Kansas City, MO 64111
www.uexpress.com

Festivals and conventions

Angouleme Cartoon Festival
www.cndbi.fr

San Diego Comic Convention
311 4th Avenue 512
San Diego 92101, USA
www.comic-con.org

Cartoonists' Web sites

www.alexhughescartoons.co.uk
www.eviltwinartworks.com
www.jamesapearson.com
www.kolossi.deviantart.com
www.spencerhill.co.uk
www.successfulcartooning.com

Bibliography

Byrne, John, *Drawing Cartoons* (HarperCollins)

Byrne, John, *Learn to Draw Cartoons* (HarperCollins)

Dean, Selina, *Drawing Manga* (HarperCollins)

Eisner, Will, *Comics and Sequential Art* (Poorhouse Press)

Hughes, Alex, *Learn to Draw Caricatures* (HarperCollins)

Lee, Stan, and Buscema, John, *How to Draw Comics the Marvel Way* (Fireside Books)

McCloud, Scott, *Making Comics: Storytelling Secrets of Comics, Manga, and Graphic Novels* (Harper Paperbacks)

McCloud, Scott, *Understanding Comics: The Invisible Art* (Harper Paperbacks)

Nordling, Lee, *Your Career in Comics* (Andrews McMeel Publishing)

Nunn, Janet, *Learn to Draw Animated Cartoons* (HarperCollins)

Graphic Artists Guild Handbook: Pricing & Ethical Guidelines, published annually (North Light Books)

The Monster Book of Manga (HarperCollins)

Index

A
acrylic paints 24
animals 38–41, 64–65
 fantasy 41
animation 172–175
anime 143, 144, 162–163
anthropomorphism 40, 64
Asterix 11

B
backgrounds 46–47
basic shapes 32–33
Batman 11
Beano, The 10
body language 62–63
bounce effect 66
bristol board 26
brushes 24

C
caricature 96–117
 creative 112–115
 live 116–117
characters 80–83, 181
 funny 84–85
 manga 146–147
charcoals 26
Chibi characters 146
clip-art images 28
colors 107
 in manga 160–161
comic strips 118–141
 comic-book style 122
 lettering 134–135
 newspaper style 120
computer(s) 19, 28–29, 162,
 167, 168–169, 170–171
 animation 174
conté 26

correction fluid 26
costumes 45, 145, 151
creatures in manga 152–153

D
Dandy, The 10
deadlines 182
drawing 16–17
 boards 19
drawing paper 26

E
electronic copies 182
e-mails 182
emotions 58–61
 enhancing 68
 in manga 148–149
exaggeration 57, 60–61,
 85
expressions 58–61, 62
 in manga 148–149
eyes 144

F
fabric paints 167
face(s) 58–61, 103–107
 shape 144
famous people 98_–101
fantasy animals 41
figures 34–37
finished art 136–141
 in manga 158–161
frames 125
"freezing" 133
funny characters 84–85

G
graphic effects 168
graphics tablets 168

H
hairdos 145
hand gestures 62–63
hard copies 182
history of cartoons 8–13
humor 72–95

I
inking 141, 160
inks 23, 24–25
Internet 170–171

J
Japanese manga comics 13
jokes 75–77, 82–83, 86
 92–93, 120, 131

L
lettering space 139
lighting 18–19
locations 46–47, 132

M
manga 13, 25, 32,
 142–163
 characters 146–147
 creatures in 152–153
 emotions in 148–149
 expressions in 148–149
 mechas 154–155
 symbols in 148, 162
marketing 176–177
mascots 152, 153
materials 18–29
measuring devices 19
mechas 154–155
models 56–57
movement 56–57
mythical beasts 152

N
New Yorker, The 10
newspaper-style comic
 strips 120–121
nibs 23
O
online galleries 170–171
onomatopoeia 134

P
page layout 124–127
paints 24
 acrylic 24
 poster 24
 watercolor 24, 168
panel grids 124–127, 136
paper 26
Peanuts 180
pencils 22–23, 136–139, 141,
 158–159, 168
pens 22–23, 159
 and ink 23
people 34–37
personalized gifts 167
perspective 47, 128–129
photo reference 50
plot lines 132
poses 150–151
poster paints 24
printers 19, 182–183

profiles 108–109
proportion 36–37, 102
props 42–45
Punch 10
puns 78–79

R
realistic comics 123
reference 48–51
 recognition 83
robots 154–155

S
scanners 19
seating 18–19
shapes 32–33
Shoujo characters 146
Shounen characters 146
shouting 70
silk-screen printing 167
smudging 22
social network sites 170
software 106, 162, 168, 169
sound effects 135
soundtracks 163
special effects 66–67
speech balloons 69–71,
 134–135, 139
speed lines 67
stick figures 56–57, 64

studio 18–19
Spiderman 11
stereotypes 80–81
storytelling 130–133,
 156–157
storyboards 132
submissions 178–179
superheroes 65
Superman 11
symbols 68
 in manga 148, 162
syndication 180–181

T
The Far Side 78, 180
themes 88–93
thought balloons 71
Tintin 11
tone awareness 141

V
vibration lines 66, 67

W
watercolors 24, 168
Web designers 171
Web sites 184
whispers 71
words combined with pictures
 86–87